FREDERICK ASHTON

Front cover:
 Margot Fonteyn and Frederick Ashton in *Façade,* 1940

Inside front cover:
 Alina Cojocaru as Cinderella, Johan Kobborg as the Prince
 in *Cinderella,* 2003

Inside back cover:
 Jaimie Tapper as Chloë, Federico Bonelli as Daphnis with
 Artists of The Royal Ballet in *Daphnis & Chloë,* 2003

Back cover:
 Frederick Ashton as Mrs Tiggy-Winkle in *The Tales of
 Beatrix Potter*

FREDERICK ASHTON

FOUNDER CHOREOGRAPHER OF THE ROYAL BALLET

EDITED BY CRISTINA FRANCHI

OBERON BOOKS
LONDON

Coventry University

First published in 2004 by the Royal Opera House
in association with Oberon Books Ltd

Oberon Books
521 Caledonian Road, London N7 9RH
Tel 020 7607 3637 Fax 020 7607 3629
oberon.books@btinternet.com
www.oberonbooks.com

ISBN 1 84002 461 5

Cover and book design: Jeff Willis

Publication Assistant: Renata Bailey

Acknowledgements: Cristina Franchi would like to thank all the
photographers and copyright holders who have allowed us to
share their wonderful images. She would also like to thank Jane
Pritchard, Archivist, Rambert Dance Company Archive, Anna
Meadmoor, Archivist, The Royal Ballet School Archive and, at the
Royal Opera House, Monica Mason, Jeanetta Laurence, Anne
Bulford, Francesca Franchi and Renata Bailey without whom this
book would not have been possible.

Printed in Great Britain by G&B Printers, Hanworth.

Photographic credits

Derek Allen 75
Richard Alston 28
Gordon Anthony, Theatre Museum, Victoria & Albert Museum
 23, 33, 37, 39
Catherine Ashmore 133
Baron, Hulton Deutsch 66
Barratt's Photo Press 76
Cecil Beaton, Sotheby's 47, 54
Dee Conway 64, 65, 68, 69, 108, inside front cover,
 inside back cover
Bill Cooper 53, 56, 84, 87, 96, 104, 105, 109, 116,
 117 (below), 131 (above), 132
Anthony Crickmay, Theatre Museum, Victoria & Albert Museum
 52, 55 (below), 61, 62, 89, 97, 98, 114, 115, 126
Pollard Crowther 24, 27
Frederika Davis 41, 43, 80, 94, 95, 99
J W Debenham, Theatre Museum, Victoria & Albert Museum
 front cover, 30–32, 34, 35, 38, 40, 42
Zoë Dominic 73, 85, 93, 118, 119
Felix Fonteyn, Royal Opera House Archives 48, 49, 70–72
GBL Wilson, courtesy of the Royal Academy of Dancing
 36 (below)
Claude Harris, London 12, 13
Roy Jones 130
Barbara Key-Seymer 22
Lenare 20, 25
Hal Linden 19
London News Agency 45
Angus McBean, courtesy of Harvard Theatre Collection,
 Harvard Univeristy Library 6
Bertram Park 17
Johan Persson 92
Rambert Dance Company Archive 16
W Reilly 128
Richardby 50
The Royal Ballet School Archive 29, 36 (above), 122
Houston Rogers, Theatre Museum, Victoria & Albert Museum
 51, 74, 83, 87, 90, 101–03, 106, 107
Roy Round 125
Maurice Seymour, print courtesy of Dancing Times 44
Donald Southern Collection, Royal Opera House Archives
 11, 58, 59, 111, 120, 121, 129, 131 (below)
The Sports and General Press Agency Ltd 86
Leslie E Spatt 60, 63, 67, 82, 91, 117 (above)
Jennie Walton 100
Rosemary Winckley 123
Roger Wood 57, 77, 78, 81

Every effort has been made to trace the photographers of all pictures
reprinted in this book. Acknowledgement is made in all cases where
photographer and/or source is known.

CONTENTS

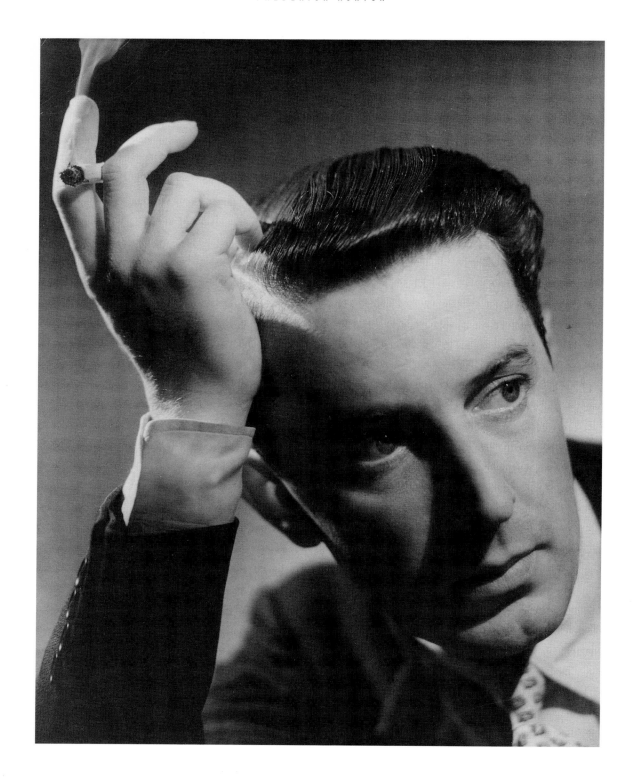

Portrait of Frederick Ashton by Angus McBean

FOREWORD

I am delighted to introduce a book, which celebrates through pictures the working life and legacy of my uncle, Fred Ashton.

Ashton, inspired by a youthful sighting of Pavlova, set out wanting to be the greatest dancer the world had ever known. He always felt a twinge of failure that he ended on a different pinnacle, as one of the world's truly great choreographers credited with creating the 'English style'.

At home, he was a very private person, full of genuine and disarming humility, but equally possessing huge natural charisma and a powerful personality under a sensitive skin. Often on entering a room he changed the atmosphere in it. And who could forget his solo curtain calls when he literally breasted the wave of applause that greeted him, then used his arms regally to beckon further applause? Once at Covent Garden, a new fireman resolved to put an end to his habit of smoking in the stalls during rehearsals only to receive the ultimate putdown, 'Don't worry dear boy, I don't inhale!' Frequently when about to be assailed by an unwanted fan or would-be friend, he would say, 'Watch me, I am invisible,' and would sail past the astonished oncomer without a flicker of recognition.

When I was young, it was his infectious humour that was so seductive. He and my mother, his youngest sister, met frequently. These sessions often started gravely enough, would progress through some of Fred's renowned and deadly impersonations, and would end with both of them in uncontrollable giggles, making them nearly ill. Their closeness was deep and necessary to each of them and was only dented momentarily when my mother heard that Fred's simpering Ugly Sister in *Cinderella* was based on her!

It was as an entertainer that many remember him, whether at home among his few close friends, or at dinner parties and society balls, or in royal circles. Amongst his closest friends and family, actual time meant nothing if he was having a good time. Lunch, even if ready to be served, could on occasion be delayed until early evening. His lateness for the Christmas turkey used to make my father seethe with silent rage, which was only made worse when Fred inevitably became the very life and soul of the party. He also had an unfailing ability to persuade close friends who stayed with him in the country to shop, cook and garden for him.

His love of the East Anglian countryside was heartfelt and an endless source of refreshment and inspiration. He was proud of being from Suffolk 'Yeoman stock', spiced by a youth spent in South America.

Throughout his life, he continually brooded on and questioned his talent, once remarking near the end of his life that, 'My ballets begin to bore me, they are too long,' and that from the master of précis!

I commend this book, which portrays some of the process of creation as well as images from many of his ballets, as we celebrate the centenary of the much honoured and much loved 'little Freddy Ashton from Peru'.

Anthony Russell-Roberts

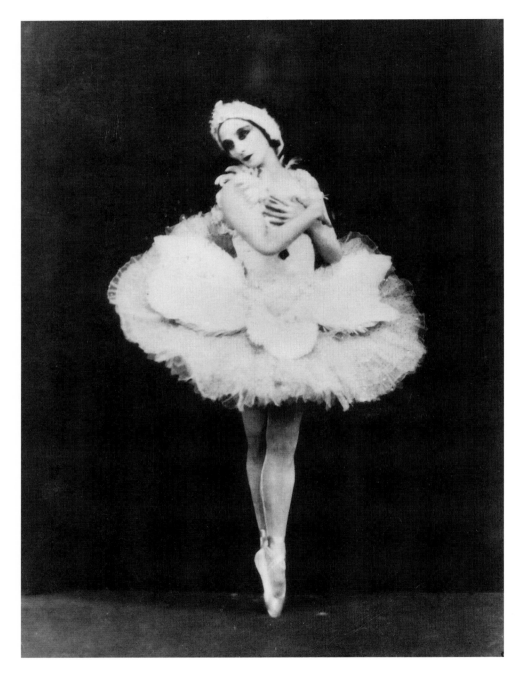

Anna Pavlova in *Le Cygne*, 1925

EARLY INFLUENCES

Frederick Ashton was born in Guayaquil, Ecuador on 17 September 1904, where his father was attached to the British Embassy as well as working in business. A few years later, the family moved to Lima, Peru and it was here that the event which was to determine the course of Ashton's life and work took place. In 1917, the 13-year-old Ashton was taken to see a performance by Anna Pavlova, the legendary Russian ballerina, who was then on an extended tour of South America. The programme opened with *The Fairy Doll* and included *Le Cygne* (*The Dying Swan*) and *Raymonda*. Ashton described later how 'seeing her at that stage was the end of me. She injected me with her poison and from the end of that evening I wanted to dance.' Pavlova's influence was to be a lifelong one and his signature 'Fred Step', a short sequence of steps seen in many of his works, was derived from her *Gavotte Pavlova*. A photograph of Pavlova in *Le Cygne* was found in Ashton's possessions after his death.

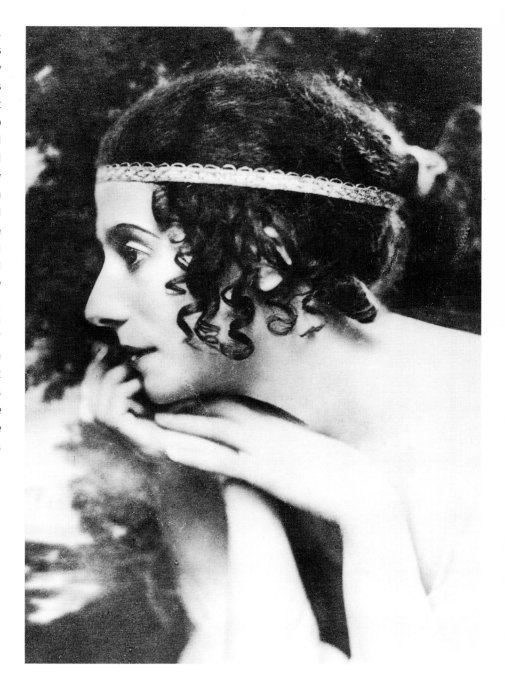

Anna Pavlova

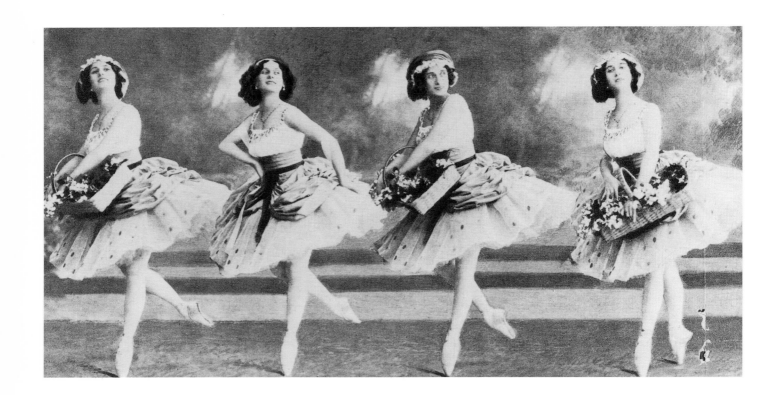

Anna Pavlova as Lise in *La Fille mal gardée*

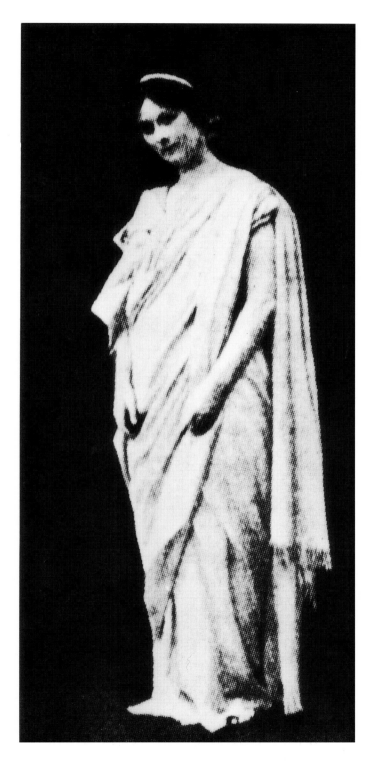

Isadora Duncan

As a young man in London in the 1920s, Ashton went to every performance of ballet and dance he could. In 1921, he went to see Isadora Duncan and was profoundly moved by her musicality, her fluidity of movement and her ability to infuse stillness on stage with emotion. For many years, Ashton thought of creating a ballet on Isadora and indeed had photographs of Margot Fonteyn in his ballet *Dante Sonata* in a quasi-Duncan pose which he had labelled Isadora. A full-length ballet was not to be, but for the Gala to celebrate fifty years of Ballet Rambert, Ashton created for Lynn Seymour *Five Brahms Waltzes in the manner of Isadora Duncan*.

Ashton was a regular attender at seasons by Diaghilev's *Ballets Russes*. The 1921 production of *The Sleeping Princess* introduced him to the genius of Marius Petipa, and Diaghilev's young choreographers such as Nijinsky and Nijinska opened his eyes to the possibilities of modern choreography. Nijinska's works such as *Le Train bleu* and *Les Biches* made a deep impression on him and she was to prove a lifelong influence.

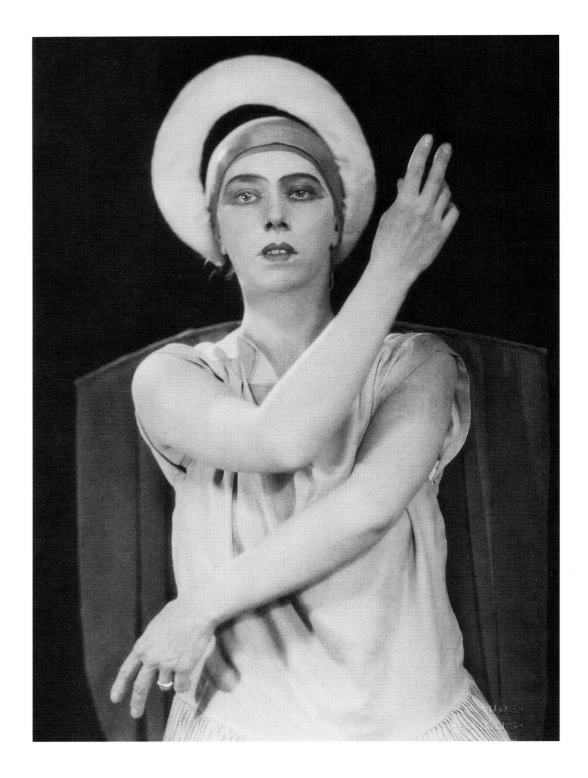

Bronislava Nijinska in *Holy Etudes* with her Théâtre Choréographique Chamber
Ensemble which toured English seaside towns in 1925

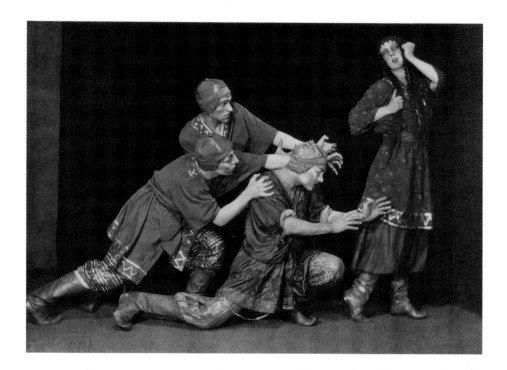

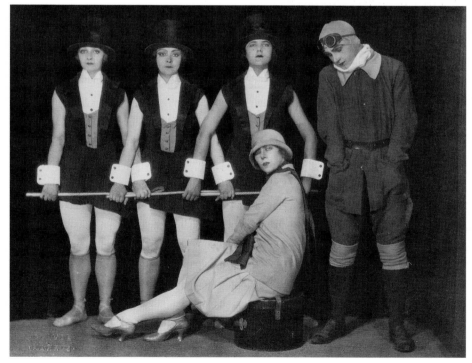

above: Bronislava Nijinska (right) in *Polovtsian Dances*, 1925
below: Bronislava Nijinska (seated) as Modiste, Soumarkova, Berry, Sohn
as Riders on Horseback, J Hoyer as the Aviator in
Touring or The Sports & Touring Ballet Revue, 1925
Théâtre Choréographique Chamber Ensemble

THE YOUNG DANCER AND CHOREOGRAPHER

Ashton was not able to pursue his dream of becoming a dancer until he was working in London. Chance led to him taking class with another *Ballets Russes* dancer and choreographer Léonide Massine. When Massine had to go to Paris, he introduced Ashton to Marie Rambert. Rambert had trained in the Cecchetti method as well as in eurythmics with Jaques-Dalcroze and Diaghilev had retained her to help Nijinsky with the rhythms for *Le Sacre du printemps*. There was no permanent British ballet company at this time so teachers such as Rambert and Ninette de Valois, who started her Academy of Choreographic Art in 1926, used every opportunity they could find for their pupils to perform, generally as part of theatrical revues.

Rambert's great skill was her ability to recognise and develop talent in her pupils. In 1926, she cajoled an extremely reluctant Ashton to try his hand at choreography and the result was his first ballet *A Tragedy of Fashion*, given as part of a revue *Riverside Nights*. This was also Ashton's first collaboration with the painter and stage designer Sophie Fedorovitch. They became great friends and worked together on many ballets until her untimely death in 1953.

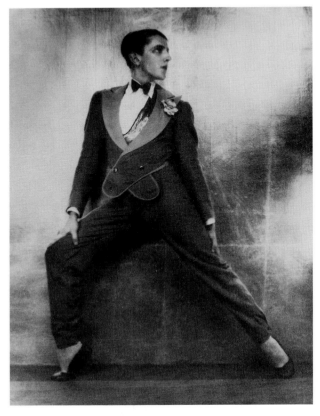

In 1928, Ashton seized the opportunity to join Ida Rubinstein's company in France for a year. The company was led by Bronislava Nijinska and Ashton later described how he learnt so much as both a dancer and choreographer through taking class with Nijinska and watching her work as a choreographer.

Ashton returned to London to become one of the founder members of Rambert's Ballet Club company, known today as Rambert Dance Company. As well as giving their own programmes, the dancers collaborated in the first ballet-only evenings organised by the Camargo Society, which was working to establish a British ballet company. Other dancers involved included *Ballets Russes* dancers such as Tamara Karsavina, Lydia Lopokova and Alicia Markova as well as Ninette de Valois and her dancers.

As well as dancing regularly, Ashton made works for The Ballet Club, including *Capriol Suite*, his earliest surviving ballet, and for the Camargo Society, while also working in musical theatre. In 1931, he made his first work *Regatta*, sadly now lost, for de Valois' new company the Vic-Wells Ballet, now known as The Royal Ballet. Ashton greatly admired Karsavina, whom he had proudly partnered in *Les Sylphides*, and Alicia Markova, with whom he danced in his Ballet Club ballets *La Péri*, *Les Masques* and *Mephisto Valse*, and both were to be lifelong influences. Also at this time, Ashton met William Chappell, an art student, who also became a dancer but more importantly was to design many Ashton ballets and to be a close friend for over sixty years.

Frederick Ashton as Monsieur Duchic in his first ballet
A Tragedy of Fashion, 15 June 1926

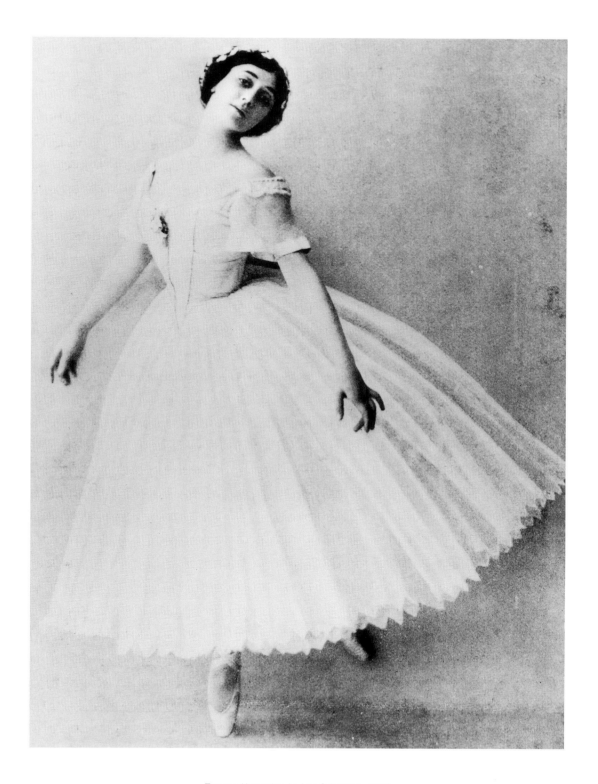

Tamara Karsavina in *Les Sylphides*, 1909

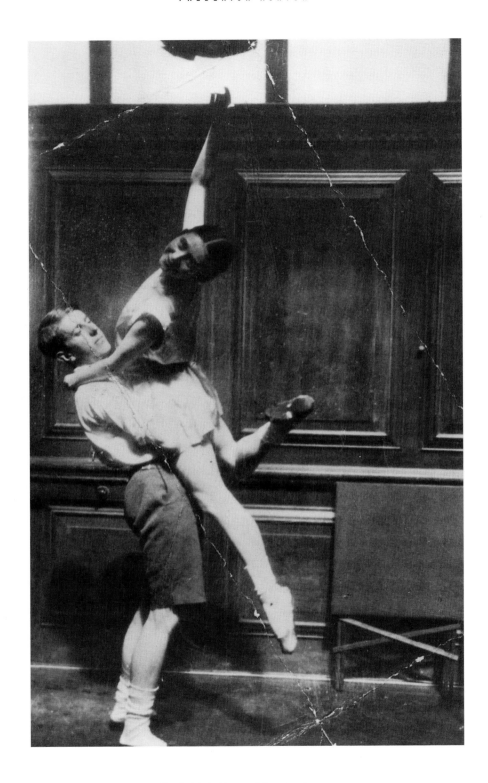

Frederick Ashton and Frances James
in an early rehearsal for *A Tragedy of Fashion*, 1926

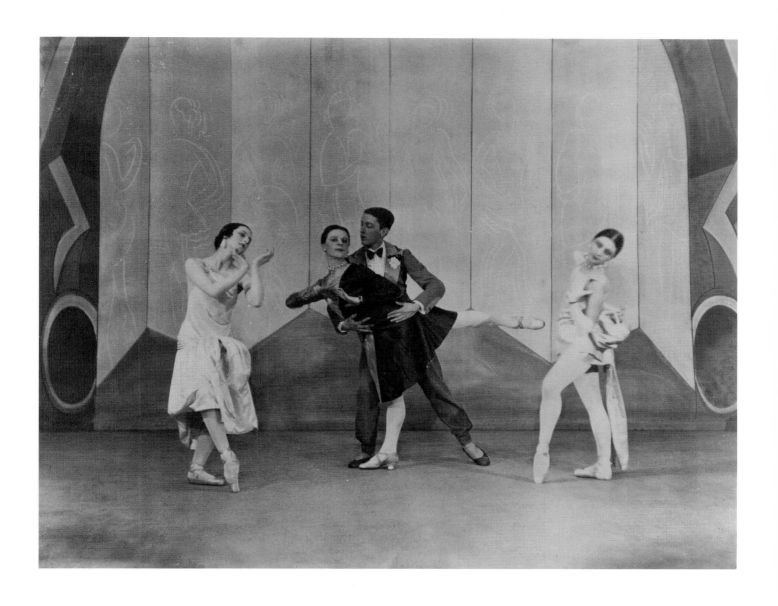

Elizabeth Vincent as Désir du Cygne, Marie Rambert as Orchidée,
Frederick Ashton as Monsieur Duchic and Frances James as Rose d'Ispahan in
A Tragedy of Fashion, 1926

PERSONALITIES

Most of the company have appeared at the Lyric, Hammersmith in one or other of the Marie Rambert Seasons, with Mme. Karsavina (who is at the head of our honorary members).

PEARL ARGYLE created the role of Venus in *Mars and Venus*. She has danced in *Les Sylphides* (*Prélude*), *Carnaval, Le Rugby, Capriol Suite*.

DIANA GOULD created Leda in *Leda and the Swan*; has danced in *Les Sylphides, Carnaval, Le Cricket, Mannequin*.

ANDRÉE HOWARD has danced in *Les Sylphides* (*Mazurka*), *Carnaval, Le Rugby, Diamond Fairy*.

PRUDENCE HYMAN created the rôle of Aurora in the Camargo Society's *Cephalus and Procris*; has danced in *Carnaval, Les Sylphides, Blue Bird* variation, &c.

ALICIA MARKOVA (guest artist) joined the Diaghilev Ballet at the age of 13; created *Chant du Rossignol*; danced in *The Cat, Cimarosiana* &c.

SUSAN SALAMAN, stage manager, is choregraphist of *Our Lady's Juggler, Le Rugby, Le Cricket, Le Boxing*. For some of these she designed also the costumes.

FREDERICK ASHTON, dancer and choregraphist, composed *Leda, Capriol Suite, Mars and Venus, A Florentine Picture, Pomona*; has danced with Mme. Lopokova in her season and partnered Mme. Karsavina in *Les Sylphides*.

WILLIAM CHAPPELL, dancer and designer of costumes for *Capriol Suite, Cephalus and Procris, Passionate Pavane* &c.

RUPERT DOONE (guest artist), a premier danseur of the Diaghilev Ballet.

ROBERT STUART, dancer in *Le Cricket, Carnaval* (the Pierrot), *Capriol Suite* and other ballets.

and

MARIE RAMBERT

The Favil Press

The First Season of

THE BALLET CLUB

Directors : MARIE RAMBERT, ASHLEY DUKES, ARNOLD L. HASKELL

Opening Monday February 16th, 1931; performances nightly (except Sundays) at 9 p.m., also Thursdays at 5 p.m. and Saturdays at 3 p.m.

2A LADBROKE ROAD, W.11

SIXPENCE

Programme for the First Season of The Ballet Club, 1931
with left to right: Harold Turner, Andrée Howard, Robert Stuart, Diana Gould,
Frederick Ashton, Pearl Argyle, William Chappell, Prudence Hyman

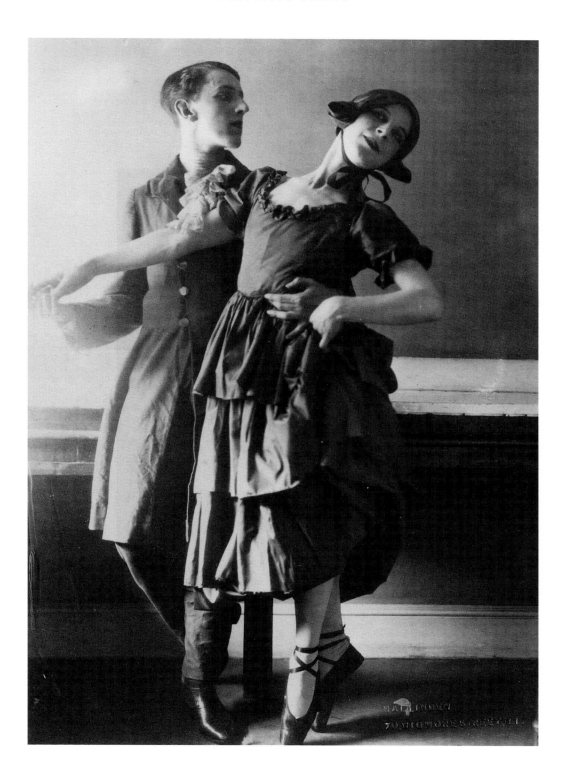

Frederick Ashton and Marie Rambert

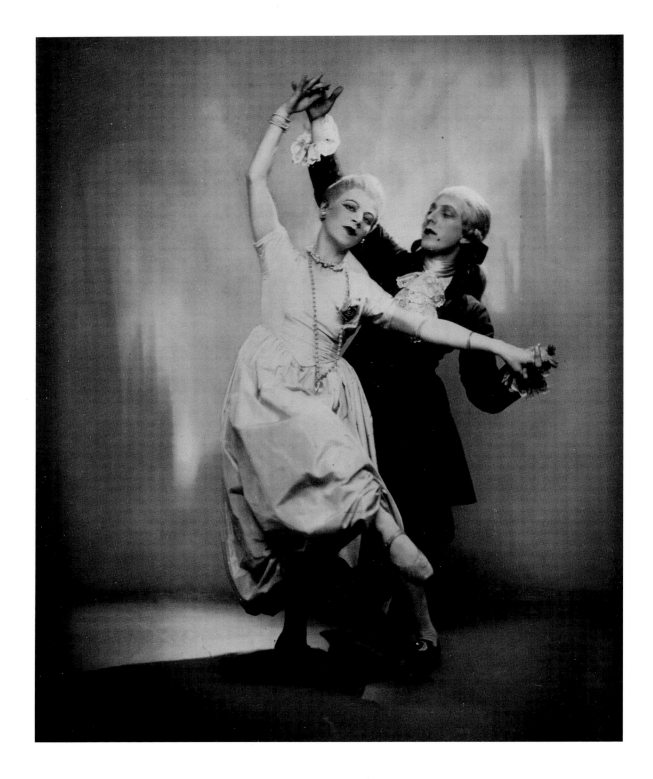

Marie Rambert and Frederick Ashton
in the *Gavotte sentimentale* from *Les Petits Riens*, 1927

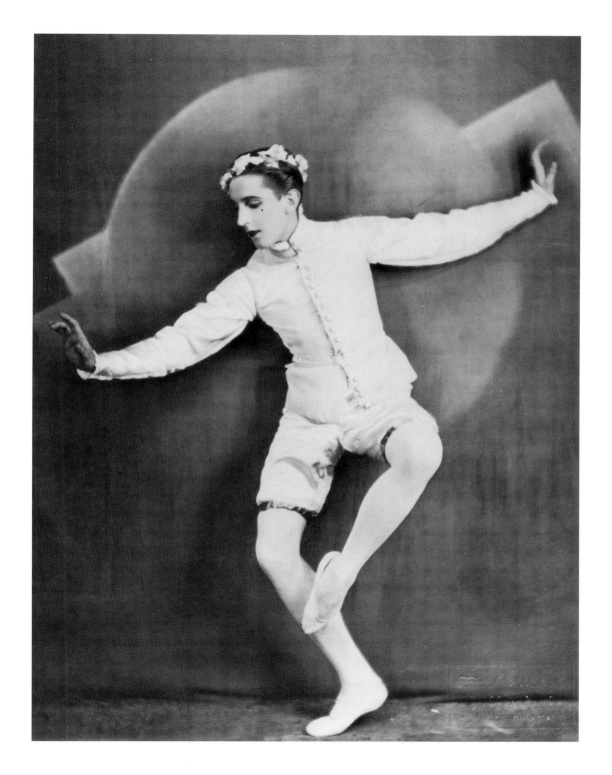

Frederick Ashton in Léonide Massine's *Les Enchantements de la fée Alcine*,
with the Ida Rubenstein Company, 1928

Frederick Ashton in *Capriol Suite*, 1930

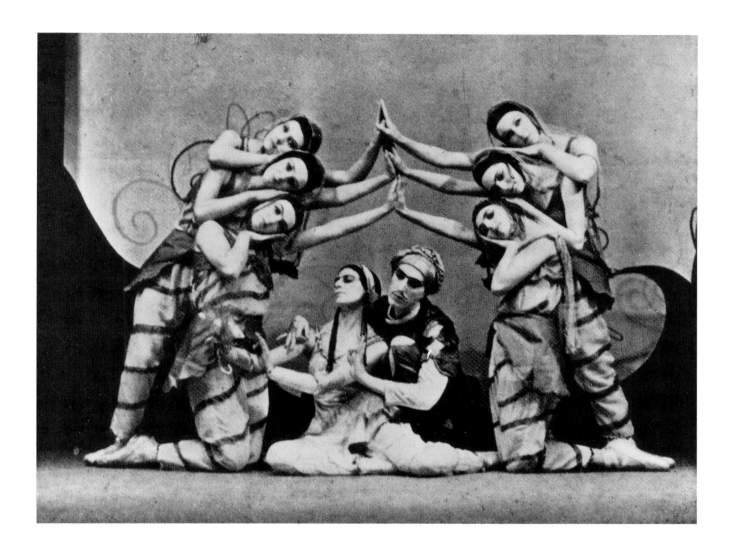

centre: Alicia Markova as the Péri, Frederick Ashton as Iskender,
with left to right: Pearl Argyle, Elisabeth Schooling, Andrée Howard, Maude Lloyd,
Susette Morfield and Betty Cuff in *La Péri*, 1931

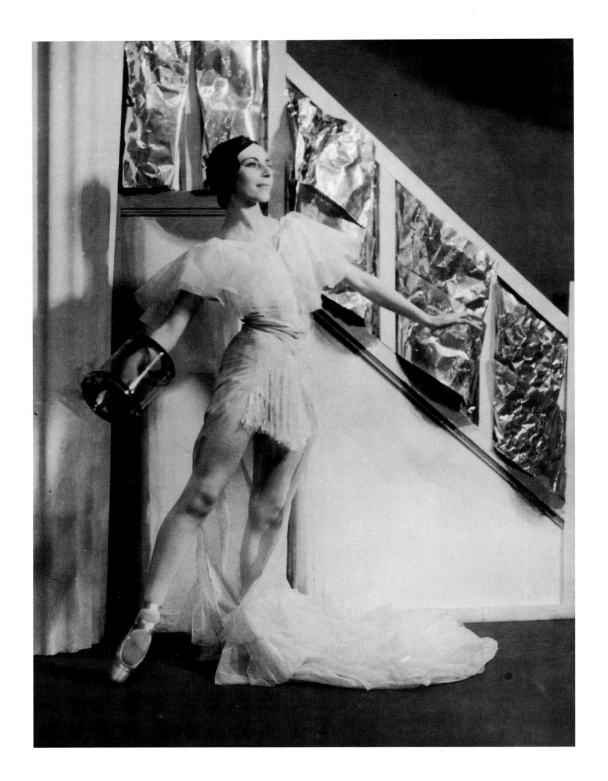

Alicia Markova as His Lady Friend in *Les Masques*, 1933

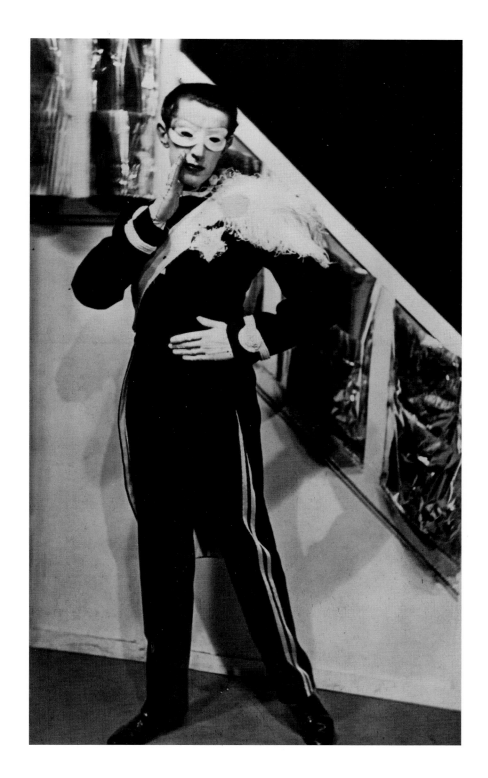

Frederick Ashton as A Personage in *Les Masques*, 1933

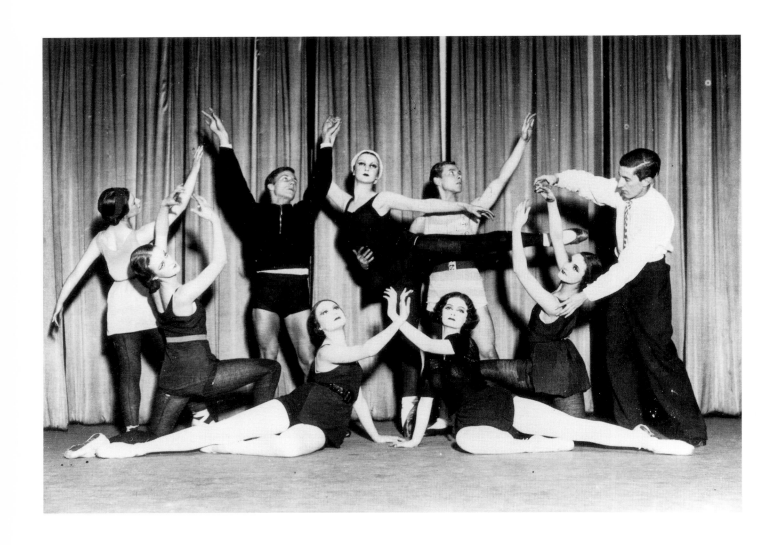

Frederick Ashton, far right, with Ballet Club dancers, 1932

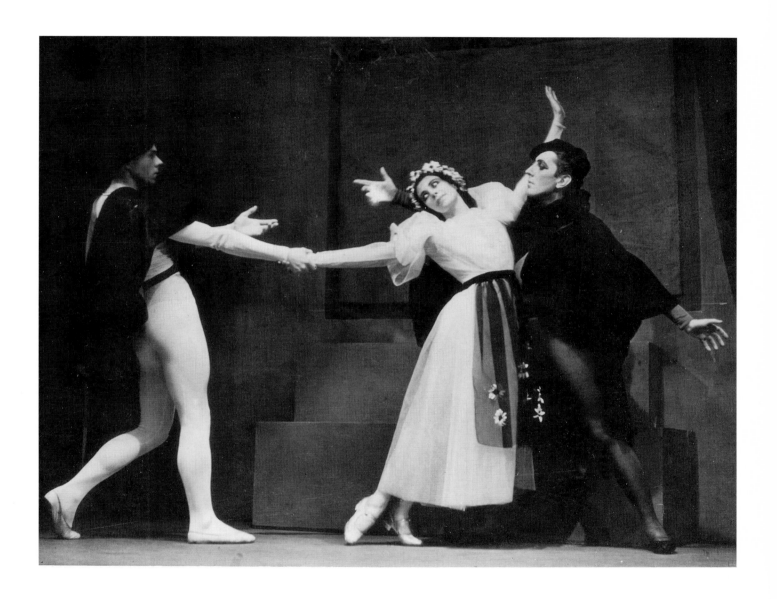

left to right: Walter Gore as Faust, Alicia Markova as Marguerite,
Frederick Ashton as Mephisto in *Mephisto Valse*, 1934

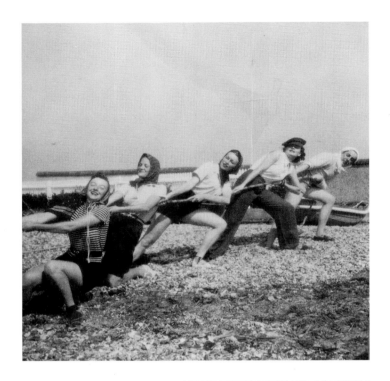

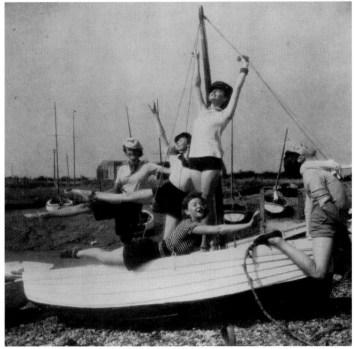

Frederick Ashton and Ballet Club dancers
enjoying a day at the seaside

VIC-WELLS BALLET

In 1935, Ninette de Valois invited Frederick Ashton to become first resident choreographer of the Vic-Wells Ballet. De Valois' vision was to create a national ballet company and in order to do that she knew she needed a talented, resident choreographer. Ashton was contracted to produce three ballets a season for a salary of £10 a week. Ashton had already made works such as *Les Rendezvous* for the Company, and new works followed, as well as revivals of earlier works such as *Rio Grande* and *Façade*.

What neither de Valois nor Ashton realised was that Ashton was to spend the rest of his working life creating works for the Vic-Wells, later Sadler's Wells Ballet, now The Royal Ballet. He did work occasionally in films, revues and musical theatre and created a small number of ballets for other companies. He also successfully directed operas at the Royal Opera House but the bulk of his choreography was to be created for The Royal Ballet.

Ashton worked with many great dancers but possibly his most significant collaboration was with Margot Fonteyn.

Although initially ambivalent towards the young Fonteyn, Ashton agreed to create a role for her in his first ballet as resident choreographer *Le Baiser de la fée*. By all accounts, rehearsals were somewhat of a battle, until one day Fonteyn burst into tears and flung her arms around Ashton's neck. This broke the stalemate and a great creative partnership developed, with Ashton creating roles for Fonteyn in these early years in *Apparitions*, *Les Patineurs*, *Nocturne* and *A Wedding Bouquet*.

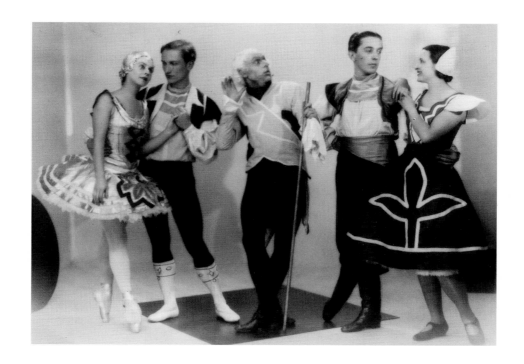

left to right: Lydia Lopokova as Swanilda, Stanley Judson as Franz,
Hedley Briggs as Dr Coppélius, Frederick Ashton and Ursula Moreton as Czárdás dancers
in *Coppélia*, Camargo Ballet Society, 1934

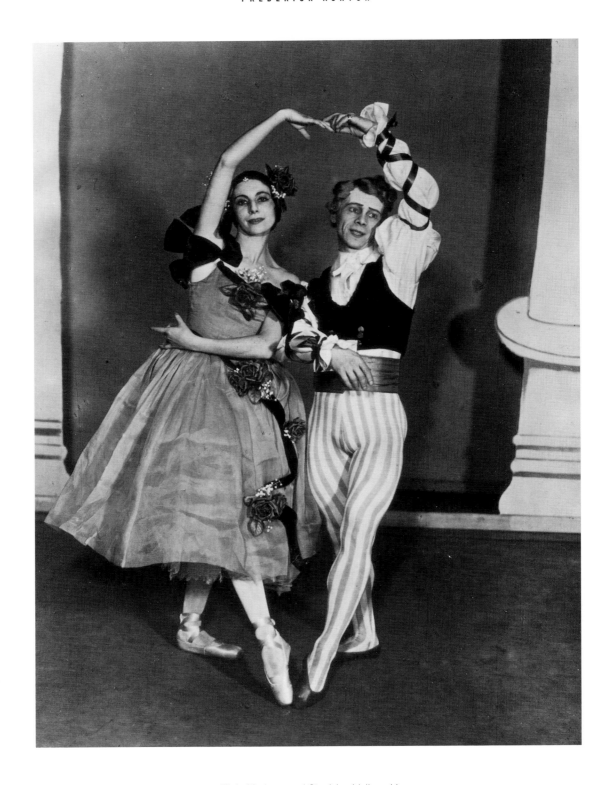

Alicia Markova and Stanislas Idzikowski
as the Lovers in *Les Rendezvous*, 1933

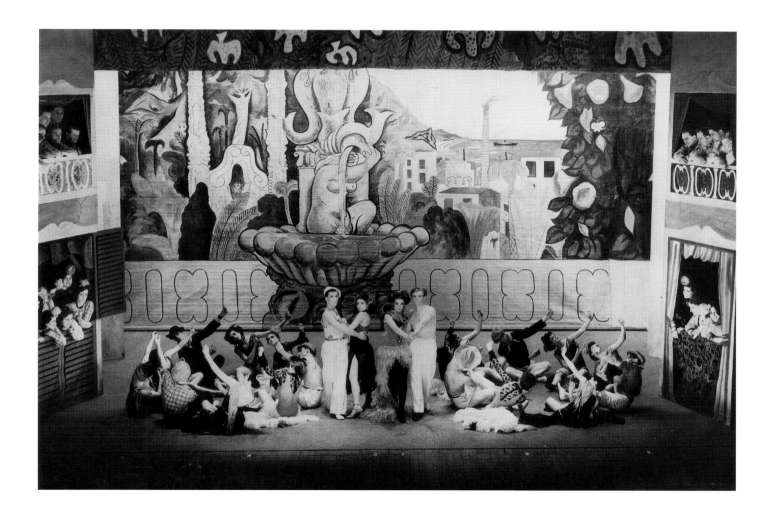

centre: William Chappell as the Creole Boy, Margot Fonteyn as the Creole Girl,
Beatrice Appleyard as the Queen of the Port and Walter Gore as the Stevedore in
Rio Grande, 1935

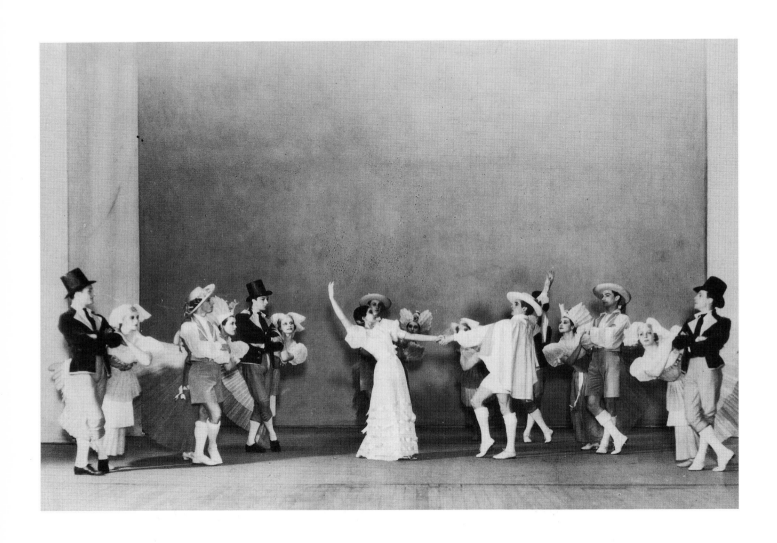

centre: Margot Fonteyn as the Fiancée,
Harold Turner as the Young Man in *Le Baiser de la fée*, 1935

FAÇADE

Façade was originally created for the Camargo Society in 1931. Based on the music composed by William Walton as a setting for poems by Edith Sitwell, it was the beginning of another important collaboration for Ashton, that with conductor and composer Constant Lambert, who became Founder Music Director of the Vic-Wells Ballet. *Façade* was taken into the repertory of the Vic-Wells Ballet in 1935, with Ashton himself appearing as the Dago, partnering Molly Brown as the Debutante in the *Tango Pasodoble*.

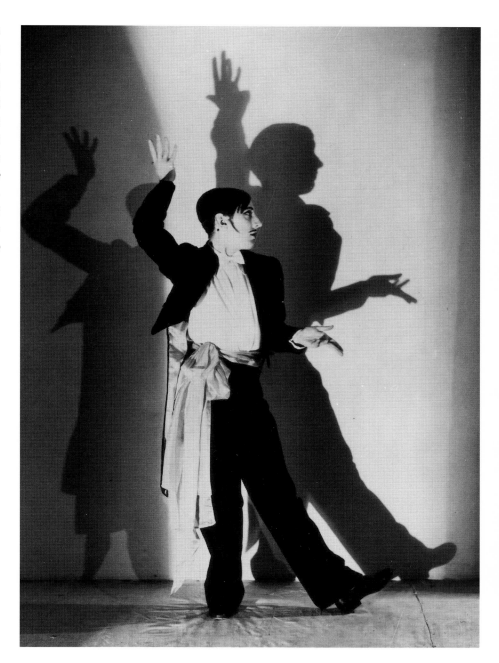

Façade, 1935 revival
Frederick Ashton as the Dago

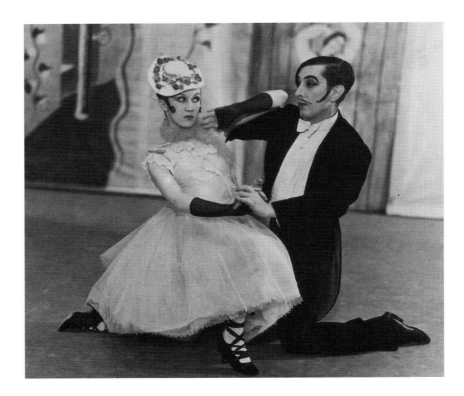

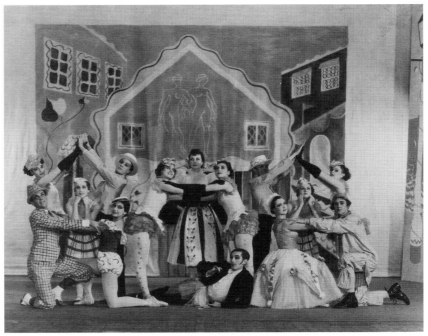

Façade, 1935 revival
above: Molly Brown as the Debutante and Frederick Ashton as the Dago
below: Final Group

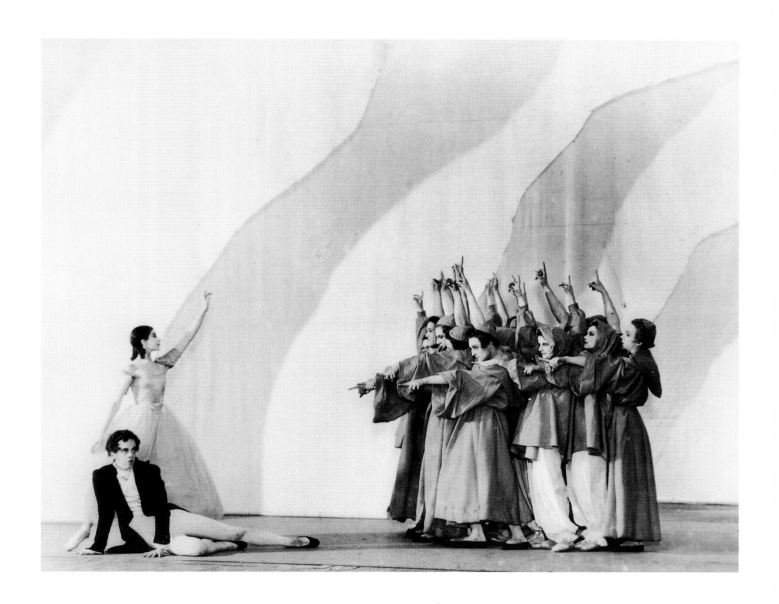

Robert Helpmann and Margot Fonteyn in *Apparitions*, 1936

above: Sophie Fedorovitch
below, left to right: Robert Helpmann, Ninette de Valois, Sophie Fedorovitch and Frederick Ashton
during a rehearsal for *Nocturne*, 1936

Frederick Ashton as A Spectator in *Nocturne*, 1936

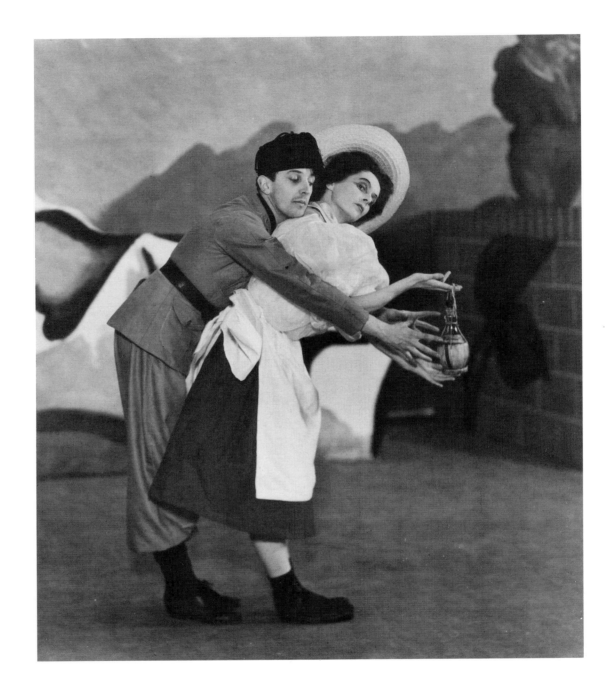

Frederick Ashton as the Sergeant, Ninette de Valois as A Peasant Woman
in de Valois' *Barabau*, 1936

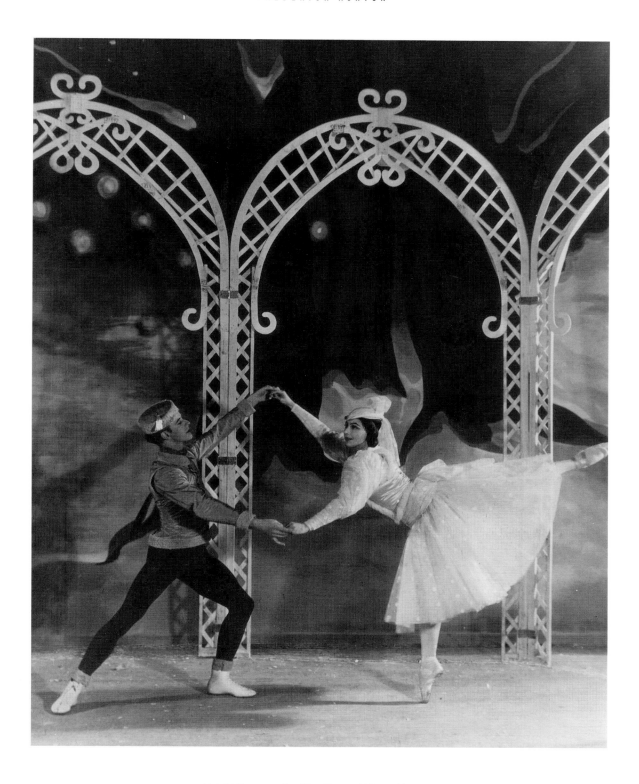

Harold Turner as the Blue Boy and Margot Fonteyn
as the White Girl in *Les Patineurs*, 1937

A WEDDING BOUQUET

A Wedding Bouquet was created in 1937, with music and designs by Gerald Berners and libretto by Gertrude Stein, and revealed Ashton's sure touch with comedy. The scenario was put together by Berners, Ashton and Lambert and tells the story of a French provincial wedding through a series of vignettes. The ballet showed off the extraordinary range of talented artists in the young Vic-Wells company, headed by Robert Helpmann as the philandering bridegroom, Mary Honer as the unsuspecting bride and with de Valois herself as Webster the formidable maid/housekeeper! The ballet remains in the repertory of The Royal Ballet to this day.

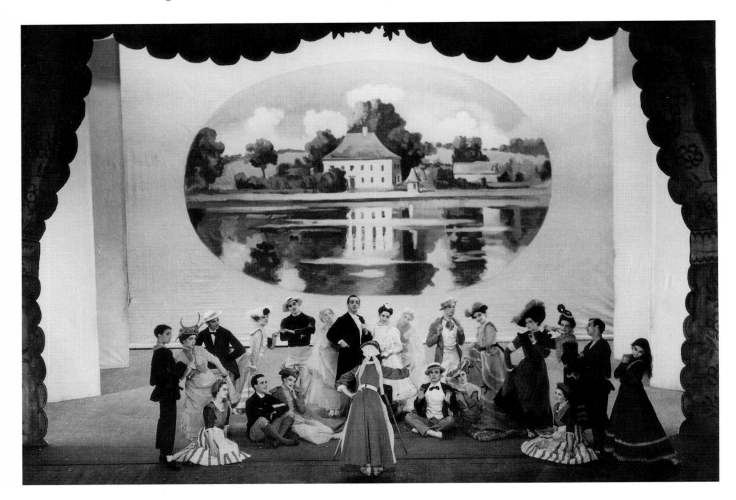

A Wedding Bouquet, 1937 Ninette de Valois as Webster takes the wedding photograph with
centre: Robert Helpmann as the Bridegroom and Mary Honer as the Bride
far right: Margot Fonteyn as Julia

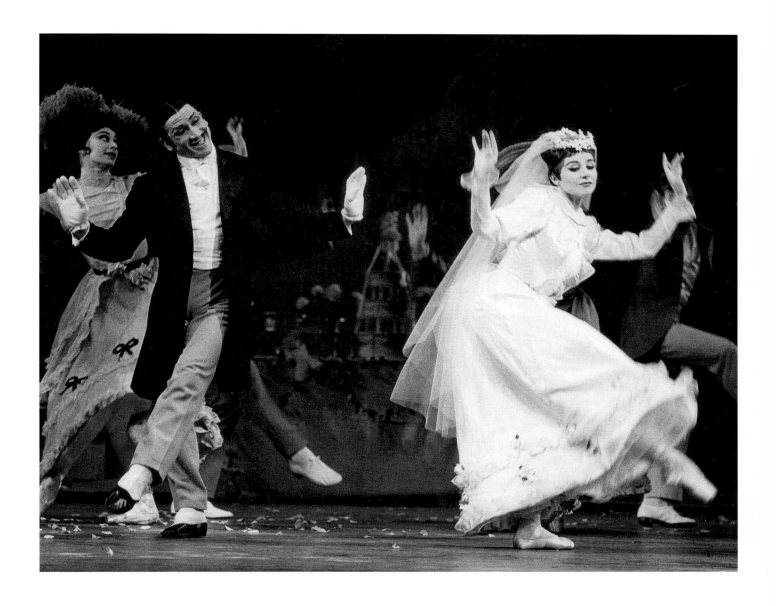

Deanne Bergsma as Josephine, Alexander Grant as the Bridegroom,
Merle Park as the Bride in *A Wedding Bouquet,* 1969

Ninette de Valois as Webster in
A Wedding Bouquet, 1937

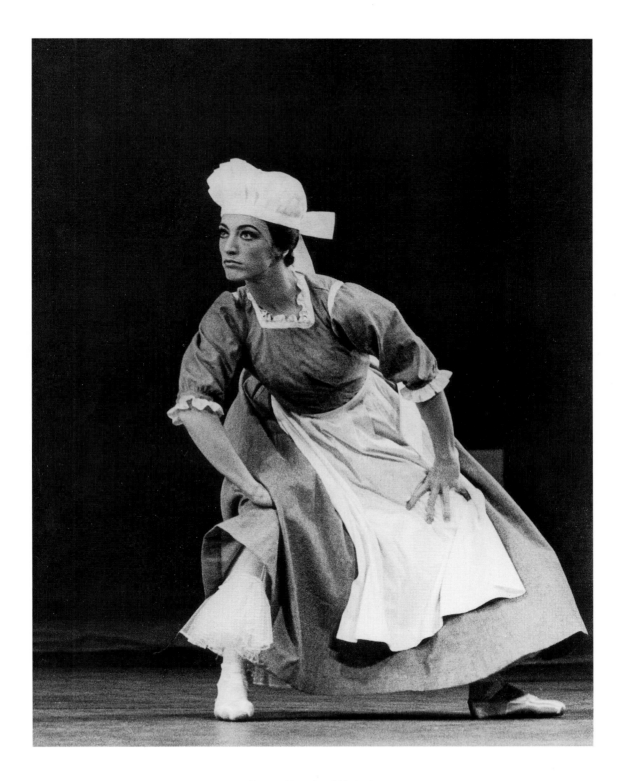

Monica Mason as Webster in
A Wedding Bouquet, 1969

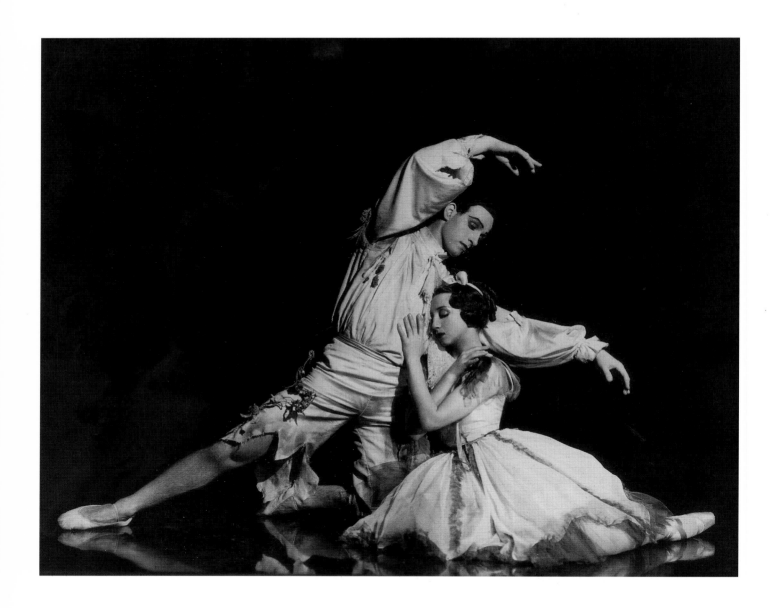

Frederic Franklin as the Young Lover, Alexandra Danilova as the Daughter in *Devil's Holiday*, 1939
A work created by Ashton for the *Ballets Russes de Monte Carlo*
Frederic Franklin worked with The Royal Ballet to recreate an excerpt from this ballet as part of the Ashton 100
celebrations in 2004, the first time any of this work had been seen in Britain

THE WAR YEARS

The outbreak of the Second World War in 1939 saw London theatres closing and suddenly Sadler's Wells Ballet, as the Vic-Wells Ballet had become known, was without a home. Ashton threw the Company into the war effort, leading tireless tours around the country. The Company appeared in church halls, small theatres and military camps, accompanied by Music Director Constant Lambert and rehearsal pianist Hilda Gaunt on two pianos! Because of this wartime touring the Company came to be regarded as Britain's national ballet company in all but name.

During the tours, Ashton and Lambert worked together on *Dante Sonata*, the most successful of the four ballets Ashton created in the war years. It was an expressionist piece, danced barefoot and depicting the struggle between The Children of Light and The Children of Darkness, with no clear victors. It found a particular resonance in those dark times.

In 1940 Sadler's Wells Ballet was sent to tour Holland as a morale booster and propaganda exercise. Whilst they were there, Germany invaded Holland. Disaster was closely averted when the Company managed to escape back to England on a cargo boat, leaving costumes, scenery, music and personal possessions behind.

By 1941, Ashton and male dancers such as Michael Somes had all been called up and the Company carried on with the Australian Robert Helpmann. Towards the end of the war, Ashton was posted to London, where in his off-duty hours, he did research for *Les Sirènes* and *Symphonic Variations*.

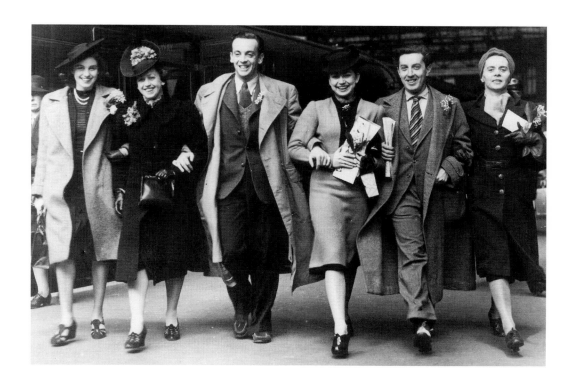

Sadler's Wells Ballet leaving London for a tour to Holland, 1940
left to right: June Brae, Mary Honer, Robert Helpmann, Margot Fonteyn, Frederick Ashton and Ninette de Valois

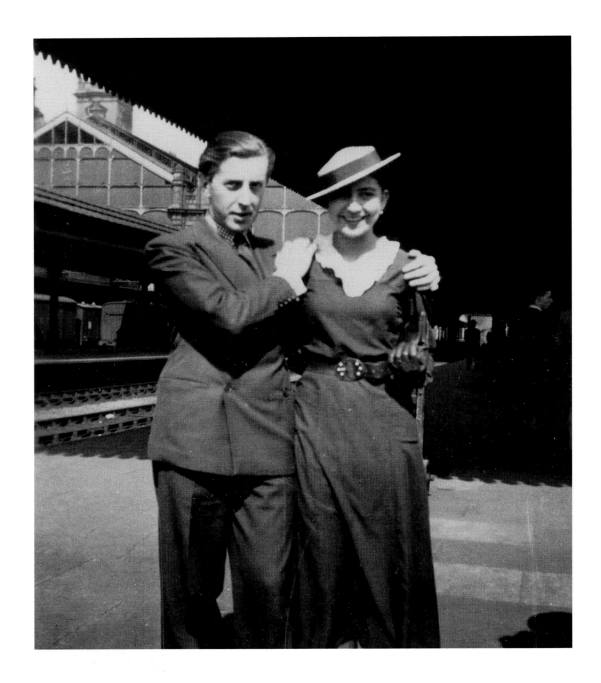

Frederick Ashton and Margot Fonteyn

Frederick Ashton in uniform

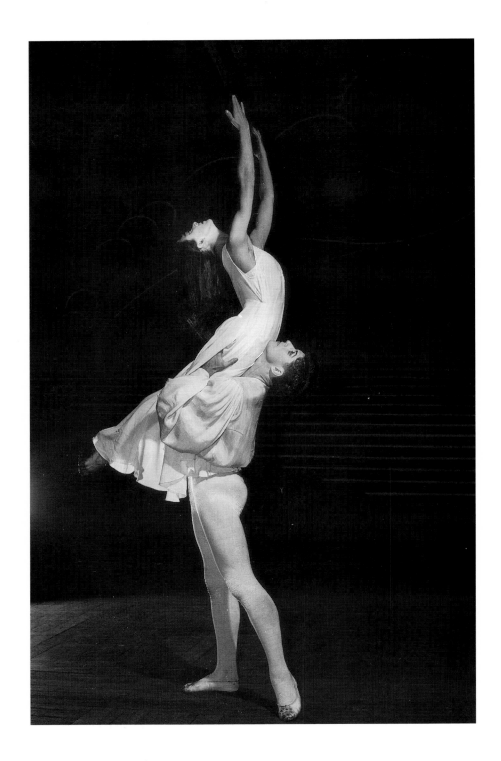

Margot Fonteyn and Michael Somes in *Dante Sonata*, 1940

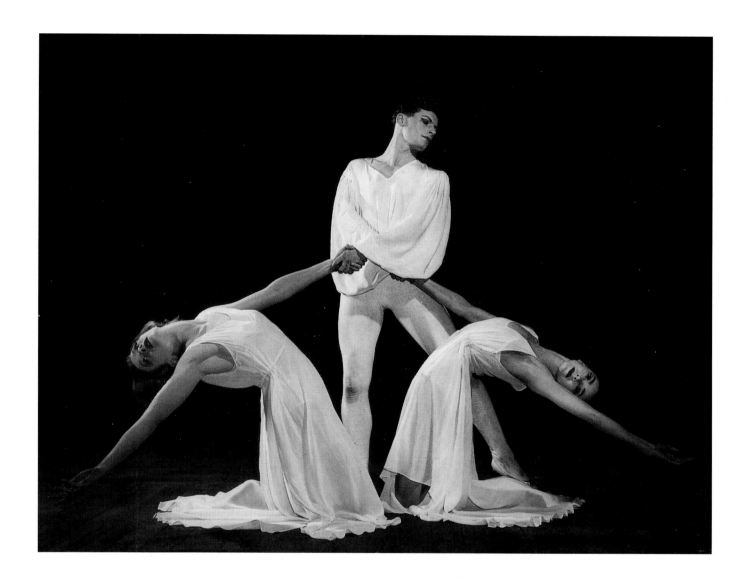

Pamela May, Michael Somes and Margot Fonteyn in *Dante Sonata*, 1940

SADLER'S WELLS BALLET MOVES TO COVENT GARDEN

After the War, Sadler's Wells Ballet was invited to make its home at the Royal Opera House, Covent Garden and the theatre reopened on 20 February 1946 in a lavish new production of *The Sleeping Beauty*. Ashton contributed choreography for the Act I Garland Dance and for the Act III *pas de trois* Florestan and his Two Sisters. Ashton's first complete work in the Company's new home was *Symphonic Variations*. Working again with Sophie Fedorovitch as designer and sounding board, Ashton created a pure classical dance work of great beauty and simplicity. The three couples were led by the incomparable Margot Fonteyn and Michael Somes, who epitomized everything Ashton was striving for.

Scènes de ballet in 1948 saw Ashton overturning preconceptions about how space could be used in ballet. He used Euclid's geometry to work out his lines and his well thumbed and annotated copy survives in The Frederick Ashton Library, now part of The Royal Ballet School Archive.

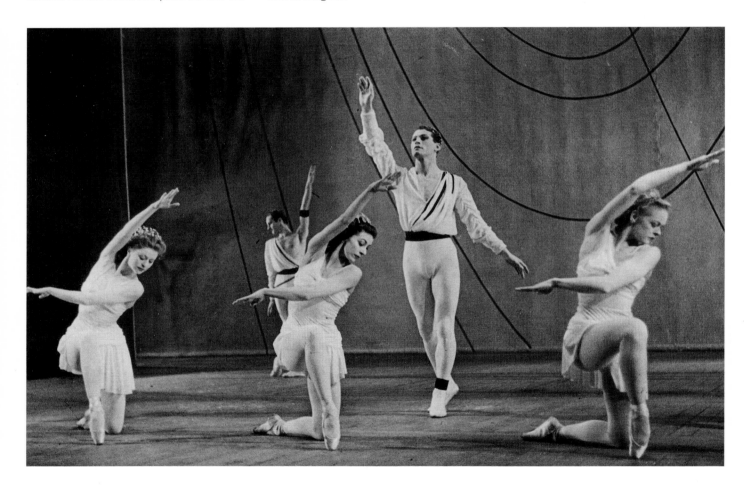

Moira Shearer, Henry Danton, Margot Fonteyn, Michael Somes
and Pamela May in *Symphonic Variations*, 1946

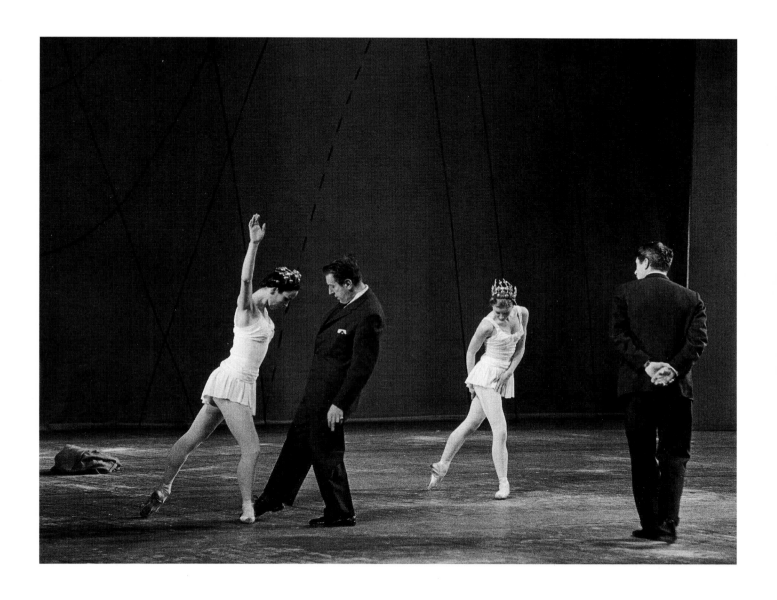

Georgina Parkinson, Frederick Ashton, Antoinette Sibley and Michael Somes
during a rehearsal of *Symphonic Variations*, 1962

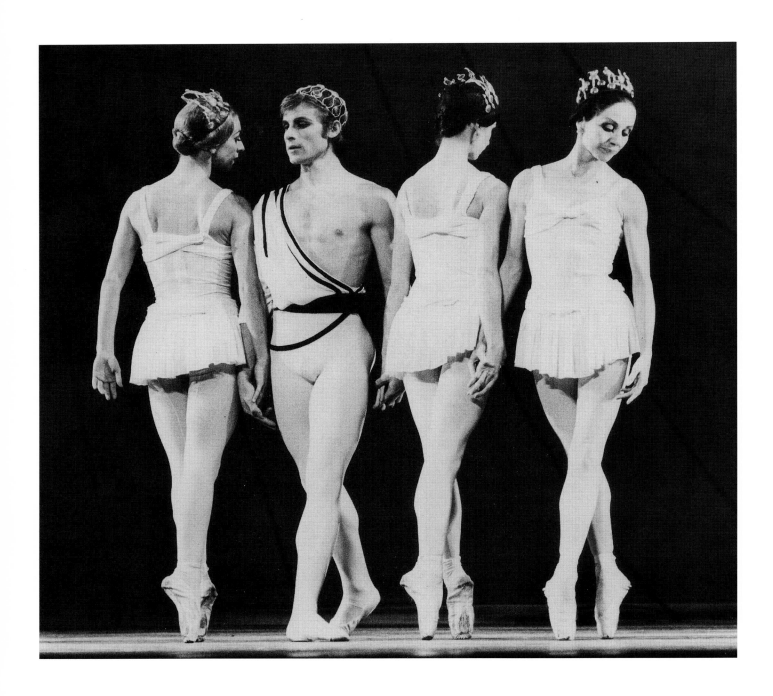

Laura Connor, David Wall, Jennifer Penney and Merle Park in
Symphonic Variations,1973

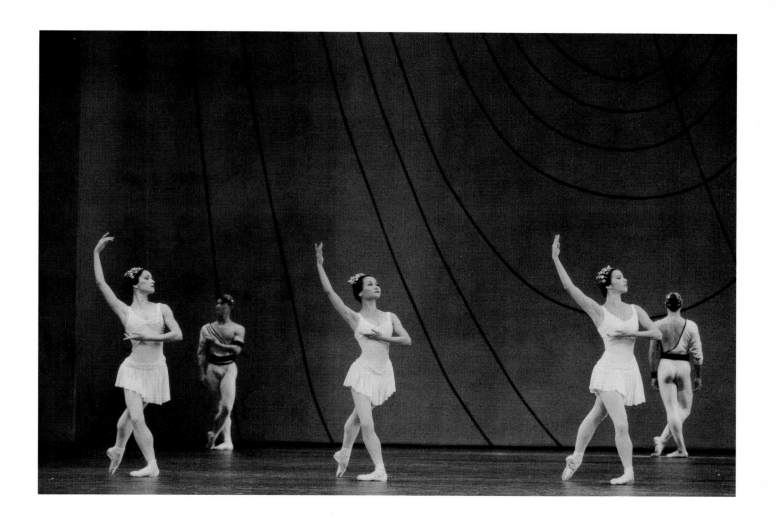

left to right: Belinda Hatley, Miyako Yoshida and Jaimie Tapper in
Symphonic Variations, 2000

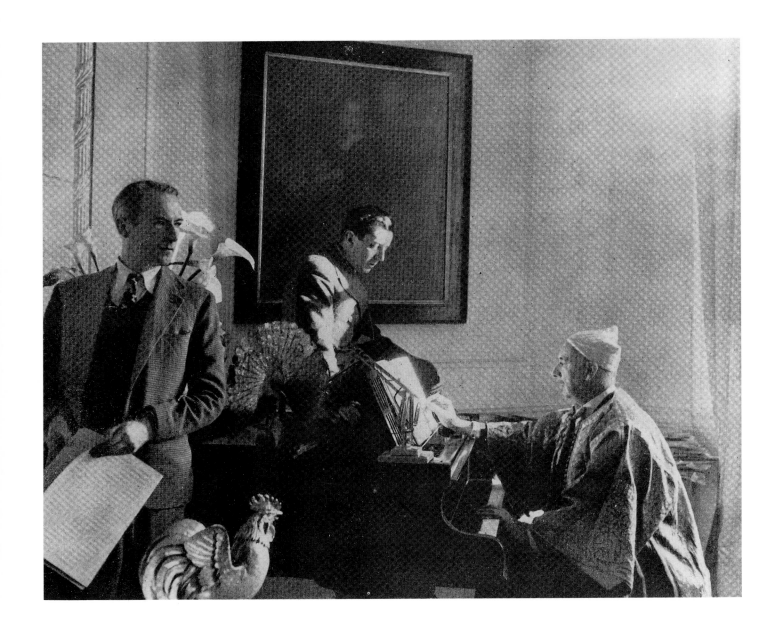

left to right: Cecil Beaton, Frederick Ashton and Lord Berners working on
Les Sirènes, 1946

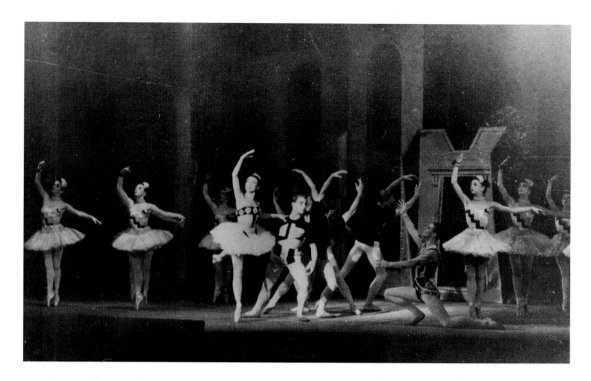

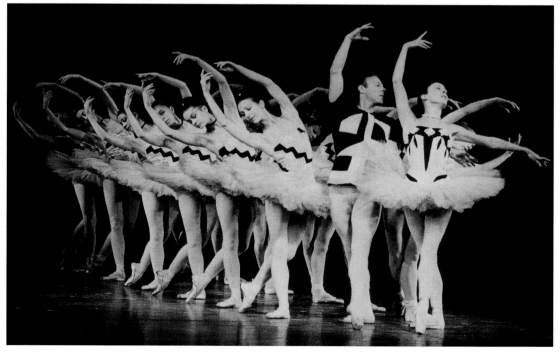

above: Margot Fonteyn, Philip Chatfield and
Michael Somes (kneeling) in *Scènes de ballet*, 1947
below: Brian Shaw and Annette Page in *Scènes de ballet*, 1960

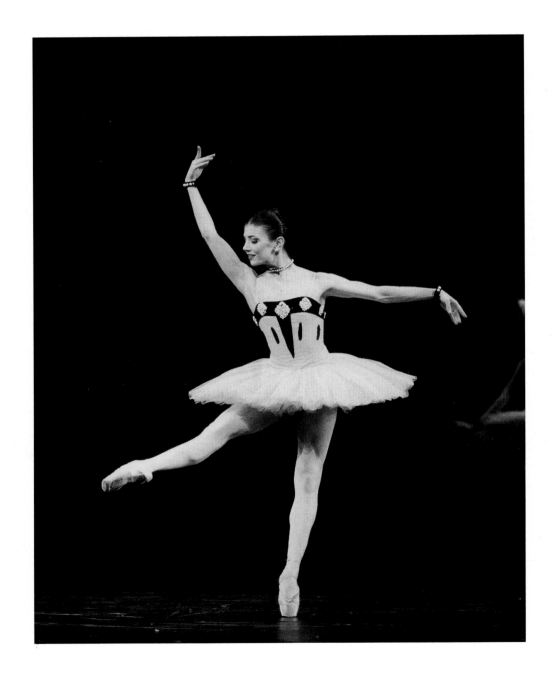

Alina Cojocaru in *Scènes de ballet*, 2003

CINDERELLA

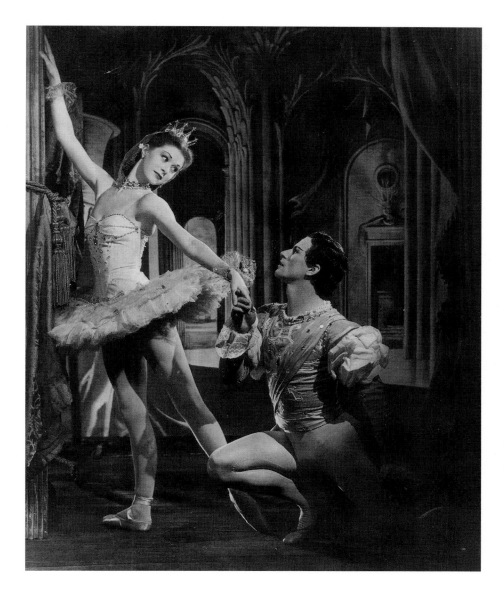

Cinderella was the first three-act ballet by a British choreographer, created by Ashton to music by Prokofiev in 1948. Ashton saw the character of Cinderella, created by Moira Shearer, 'not only as a fairytale character but also as a real person, feeling, experiencing and moving among us'. A person generous with her love and with her mercy. The Prokofiev music attracted him because it conveyed 'the poetic love of Cinderella and The Prince, the birth and flowering of that love, the obstacles in its path and finally that love fulfilled'. Ashton weaved together elements of fairytale, Victorian music hall and pantomime and created figures of pathos as well as fun in the two Stepsisters, memorably brought to life by Robert Helpmann and Ashton himself. Michael Somes was the noble Prince and the Jester was created to show off the virtuoso talents of Alexander Grant. In 2003, Wendy Ellis Somes produced a revival of *Cinderella* for The Royal Ballet, with Alina Cojocaru as Cinderella and Johan Kobborg as The Prince.

Moira Shearer as Cinderella
and Michael Somes as The Prince
in *Cinderella*, 1948

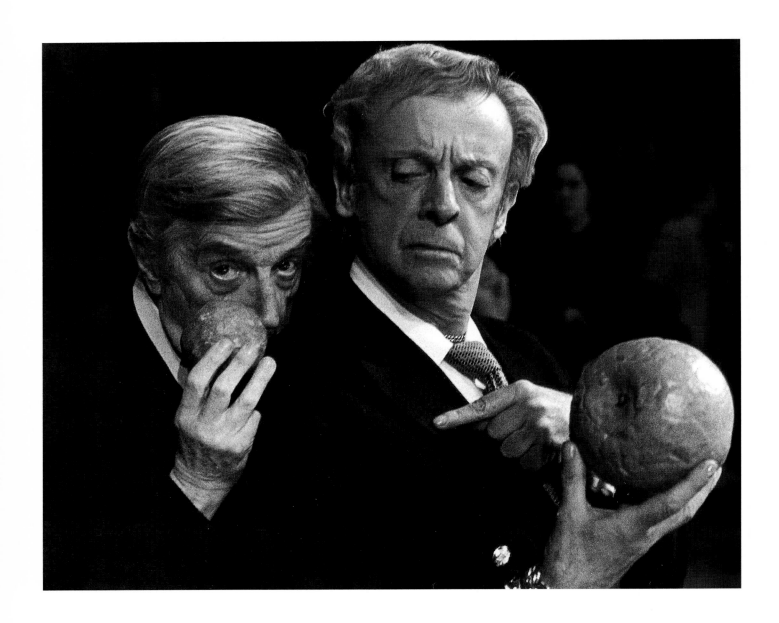

Frederick Ashton and Robert Helpmann in rehearsal for *Cinderella*, 1965

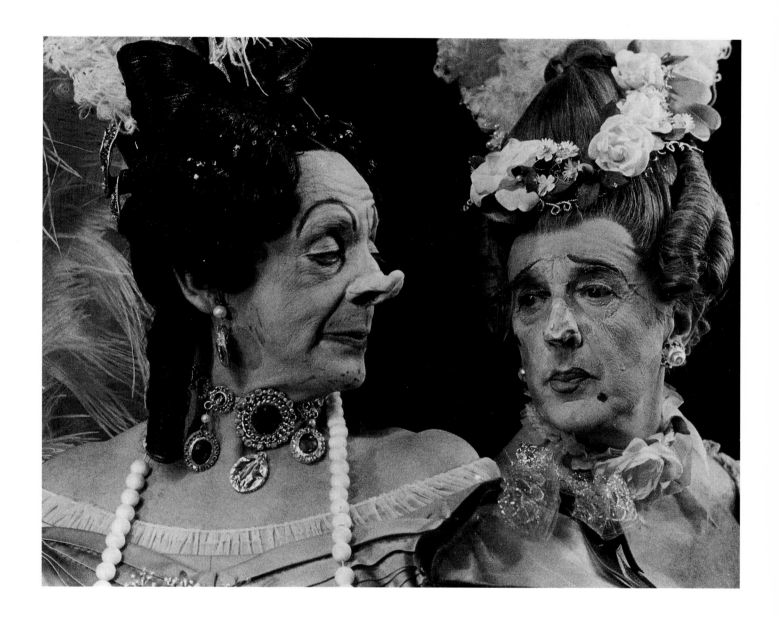

Robert Helpmann and Frederick Ashton as the Stepsisters in
Cinderella, 1965

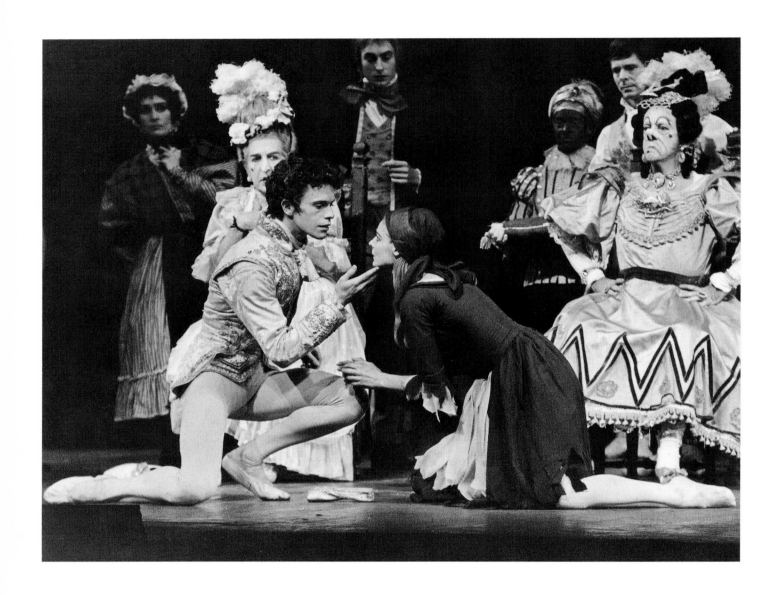

Anthony Dowell as the Prince, Antoinette Sibley as Cinderella with Frederick Ashton
and Robert Helpmann as the Stepsisters (seated behind) in *Cinderella*, 1965

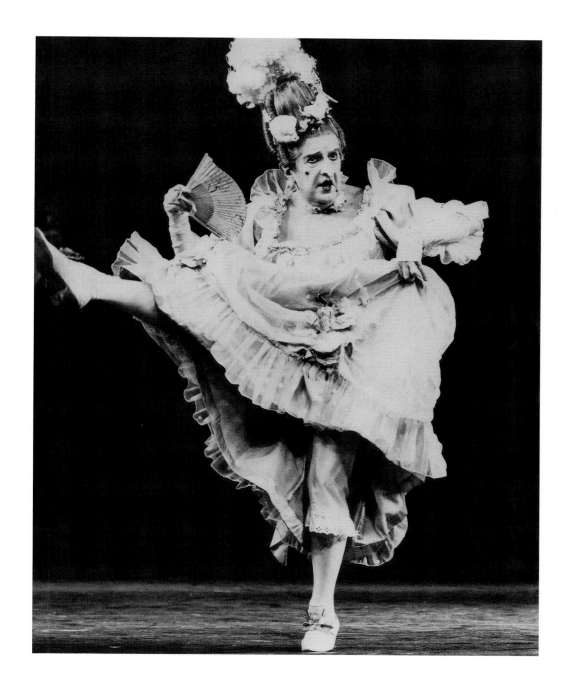

Frederick Ashton as a Stepsister in *Cinderella*, 1965

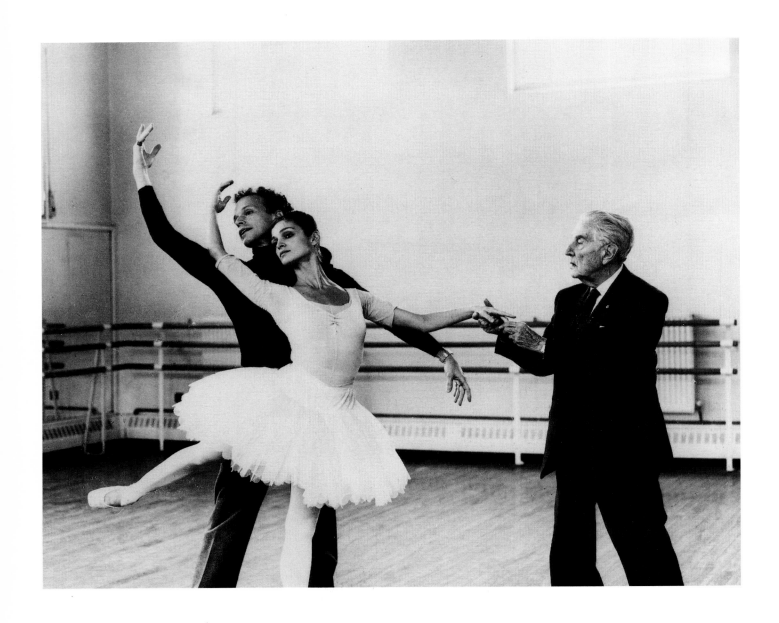

Frederick Ashton in rehearsal with Maria Almeida and Anthony Dowell
for her debut in *Cinderella*, 1987

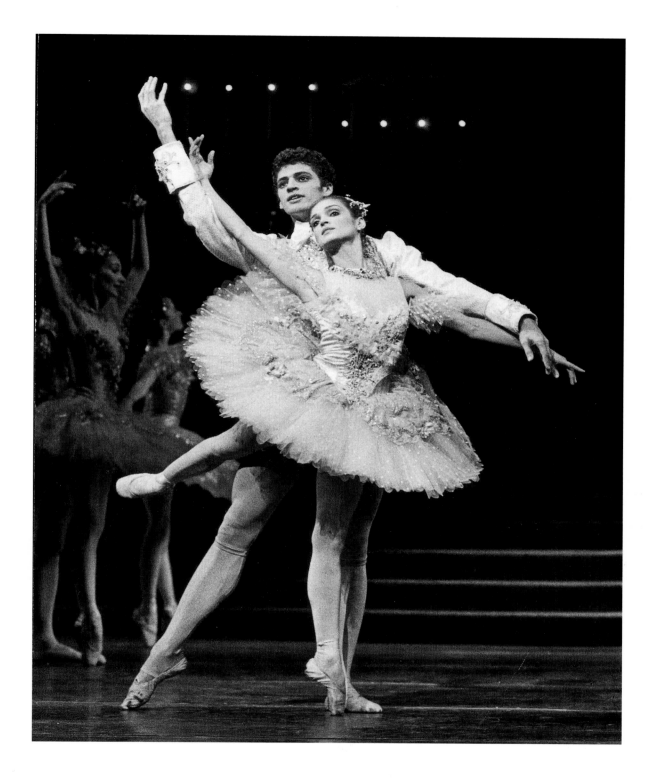

Maria Almeida as Cinderella and Jonathan Cope as The Prince in
Cinderella, 1987

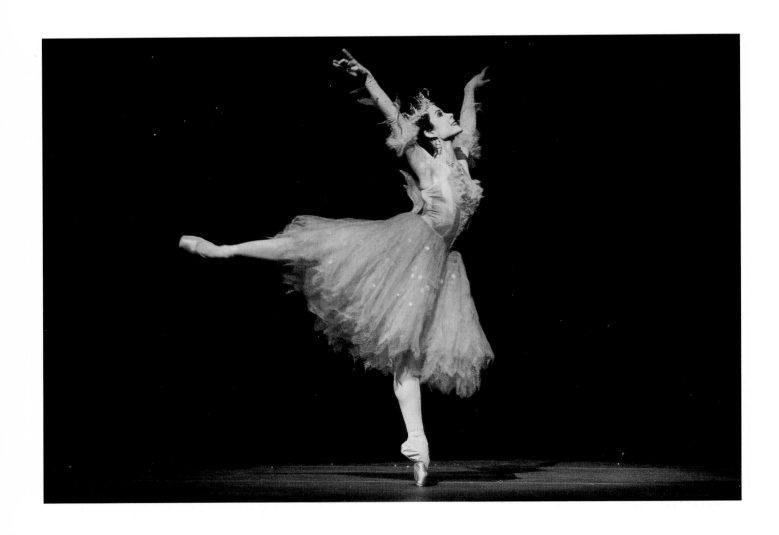

Isabel McMeekan as The Fairy Godmother in
Cinderella, 2003

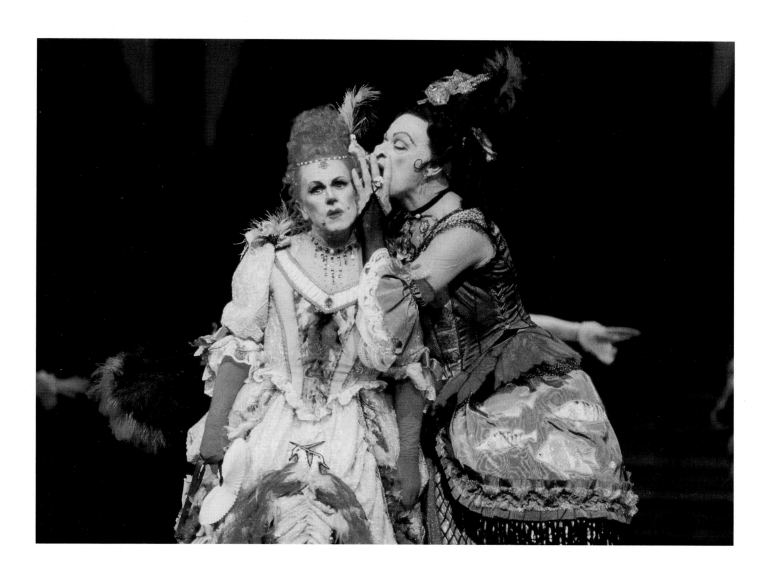

Wayne Sleep and Anthony Dowell as the Stepsisters in
Cinderella, 2003

DAPHNIS AND CHLOË

Ashton created *Daphnis and Chloë* in 1951, using the Ravel score originally commissioned by Serge Diaghilev in 1921 for the *Ballets Russes* production with choreography by Fokine. Tamara Karsavina, the original Chloë, encouraged Ashton to create his own version. Ashton took the radical decision to stage the work on pointe, in modern dress, with designs by John Craxton, to distance it from Greek style productions with 'people running around in tunics and veils and scarves'. *Daphnis and Chloë* explores the nature of love; it gave Margot Fonteyn one of her greatest roles. It returned to The Royal Ballet repertory in a new production, redesigned by John Craxton, in 2004.

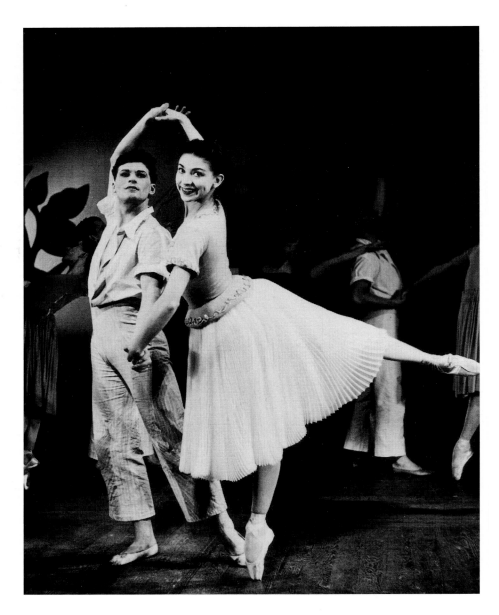

Michael Somes as Daphnis and Margot Fonteyn as Chloë in
Daphnis and Chloë, 1951

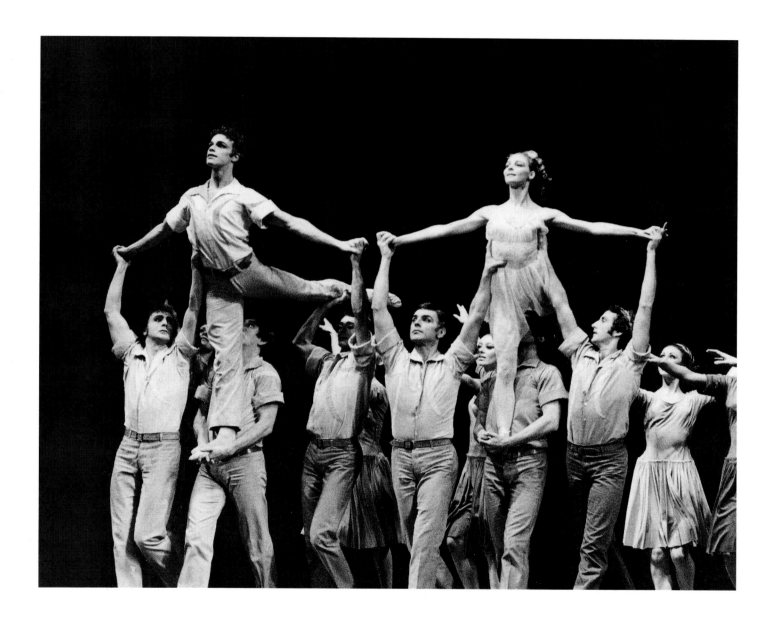

Anthony Dowell as Daphnis, Antoinette Sibley as Chloë in
Daphnis and Chloë, 1969

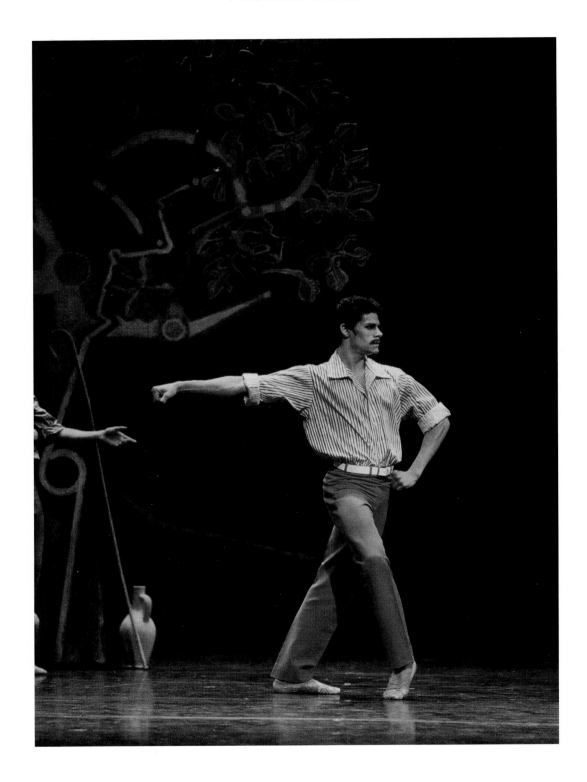

Thiago Soares as Bryaxis in
Daphnis and Chloë, 2004

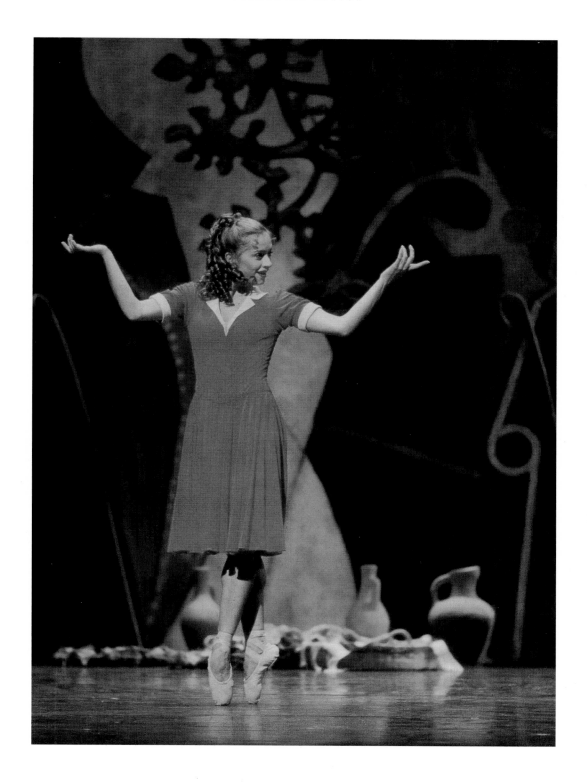

Marianela Nuñez as Lykanion in
Daphnis and Chloë, 2004

SYLVIA

Ashton created the three-act ballet *Sylvia* in 1952. His inimical summary of the plot was: 'Boy loves girl, girl captured by bad man, girl restored to boy by god.' He created the ballet for Fonteyn and the ballet critic Clive Barnes reviewing the ballet in 1952 wrote 'the part has everything for Fonteyn. It exploits her imperiousness, her tenderness, her pathos, her womanliness, her bravura… The range of her dancing is unequalled, the heart splitting significance she can give to a simple movement unsurpassed. The whole ballet is like a garland presented to the ballerina by her choreographer.' *Sylvia* was recreated for The Royal Ballet Ashton 100 celebrations in 2004 by Christopher Newton, who was in the original production and who worked closely with Ashton as dancer and ballet master.

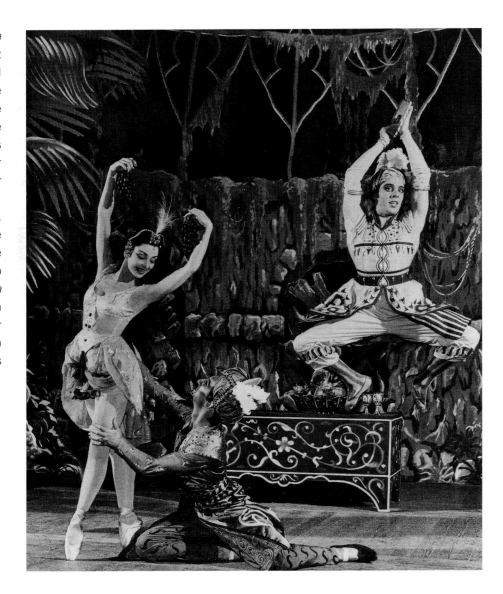

Margot Fonteyn as Sylvia, John Hart as Orion
and Brian Shaw as a Slave in *Sylvia*, 1952

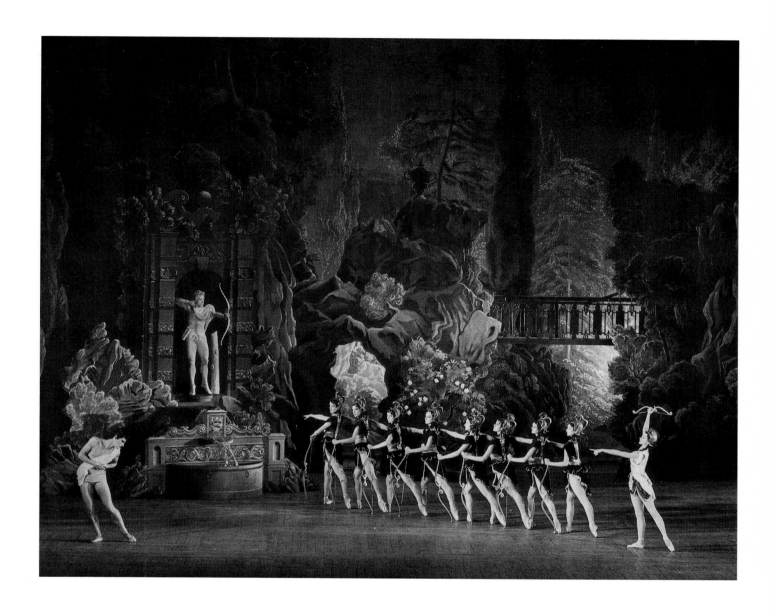

Michael Somes as Aminta,
Alexander Grant as Eros, Margot Fonteyn as Sylvia in
Sylvia, 1952

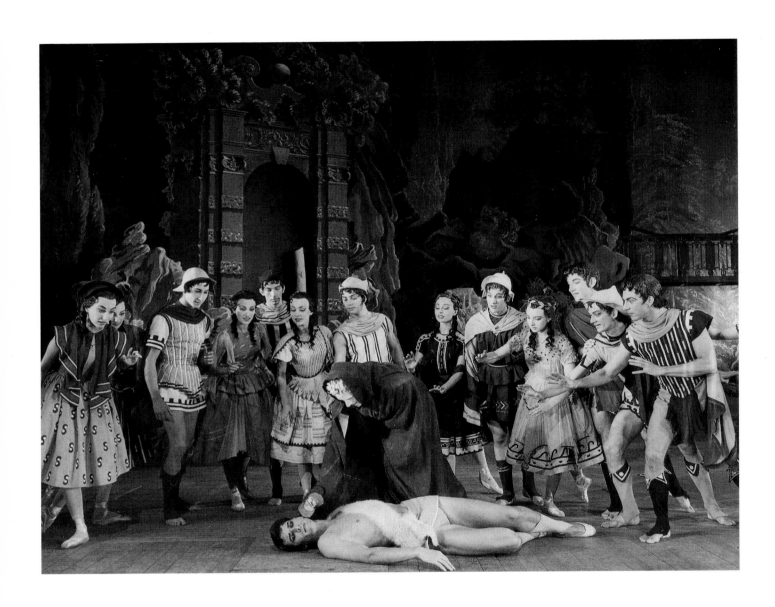

Michael Somes as Aminta, Alexander Grant as Eros
and Artists of Sadler's Wells Ballet in *Sylvia*, 1952

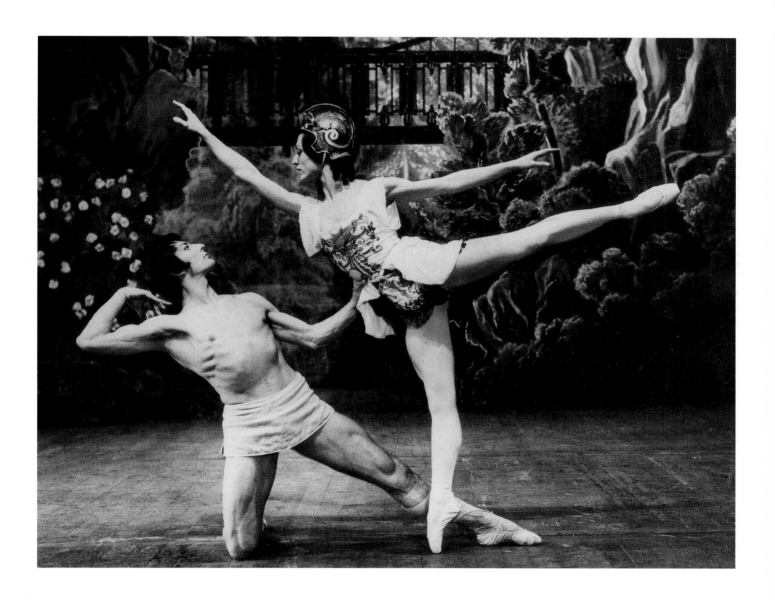

Keith Rosson as Aminta and Monica Mason as Sylvia in
Sylvia, 1968

left to right: Rosemary Lindsay, Philip Chatfield, Beryl Grey as Queen of Fire, Alexander Grant as Spirit of Fire, Bryan Ashbridge and Svetlana Beriosova in *Homage to the Queen,* The Coronation Ballet, 1953

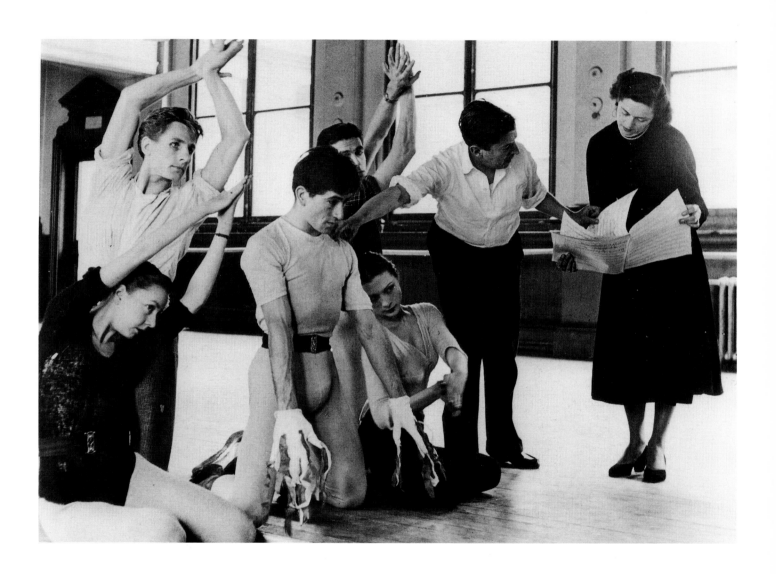

left to right: Rosemary Lindsay, Philip Chatfield, Alexander Grant, Bryan Ashbridge,
Svetlana Beriosova, Frederick Ashton and pianist Jean Gilbert in rehearsal for *Homage to the Queen*, 1953

25 YEARS OF SADLER'S WELLS BALLET

Ashton celebrated the 25th anniversary of the founding of the Company by creating *Birthday Offering* as a tribute to Ninette de Valois. *Birthday Offering* was planned as a great classical showcase for the Company's seven dazzling prima ballerinas Margot Fonteyn, Svetlana Beriosova, Violetta Elvin, Elaine Fifield, Beryl Grey, Rowena Jackson, Nadia Nerina and their partners. Ashton devised a variation for each ballerina to reveal her unique gifts.

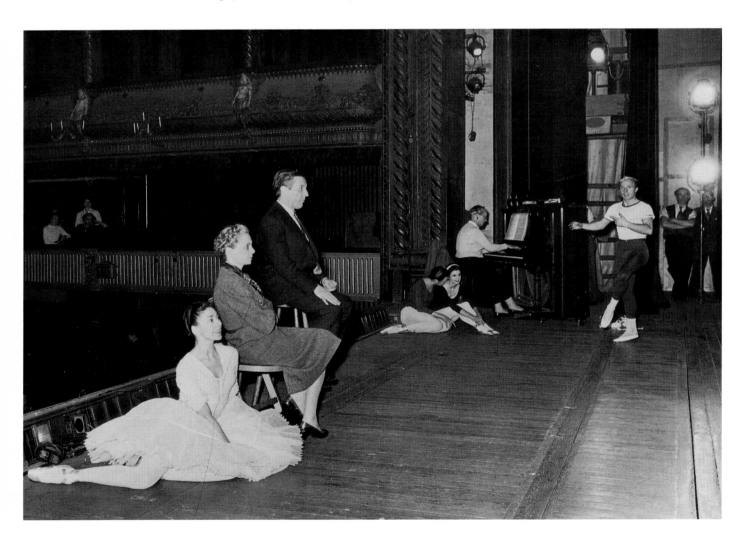

left to right: Margot Fonteyn,
Ninette de Valois and Frederick Ashton during a rehearsal for
Birthday Offering, 1956

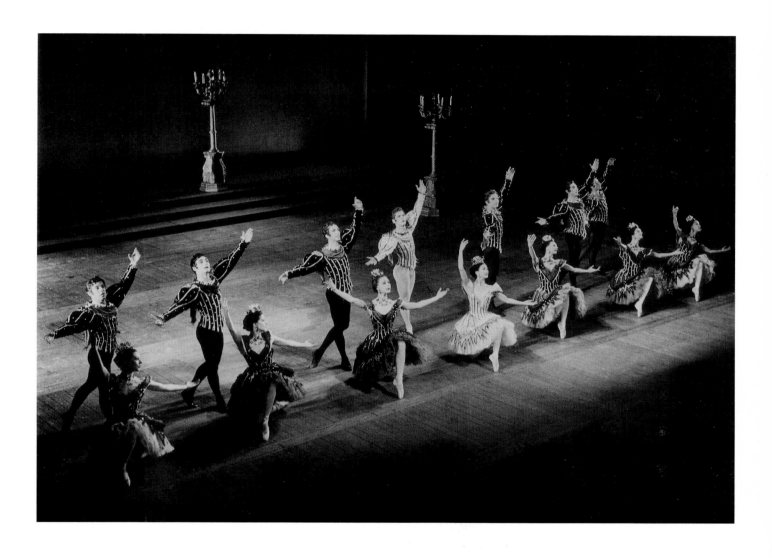

left to right: Brian Shaw and Elaine Fifield, David Blair and Violetta Elvin, Bryan Ashbridge
and Svetlana Beriosova, Michael Somes and Margot Fonteyn, Philip Chatfield and Beryl Grey, Desmond Doyle
and Rowena Jackson, Alexander Grant and Nadia Nerina in *Birthday Offering*, 1956

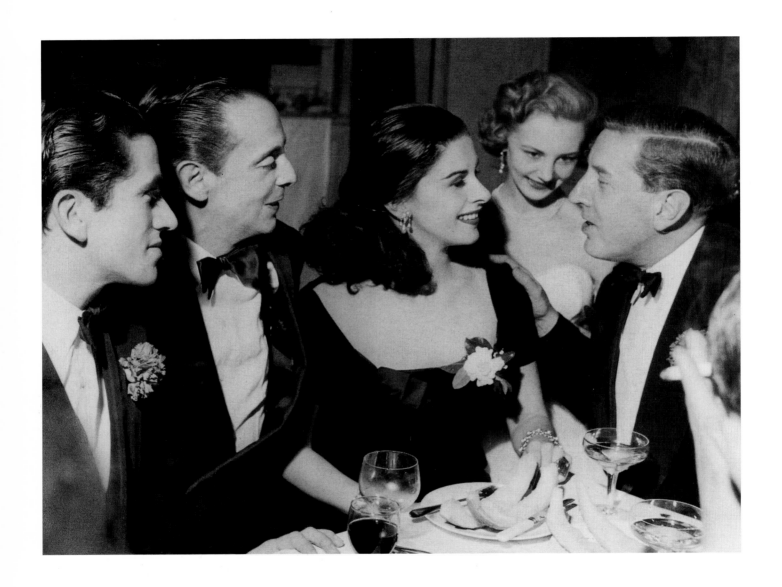

left to right: Alexander Grant, Robert Helpmann, Violetta Elvin,
Brenda Taylor and Frederick Ashton after the special performance
to mark the 25th Anniversary of Sadler's Wells Ballet, 5 May 1956

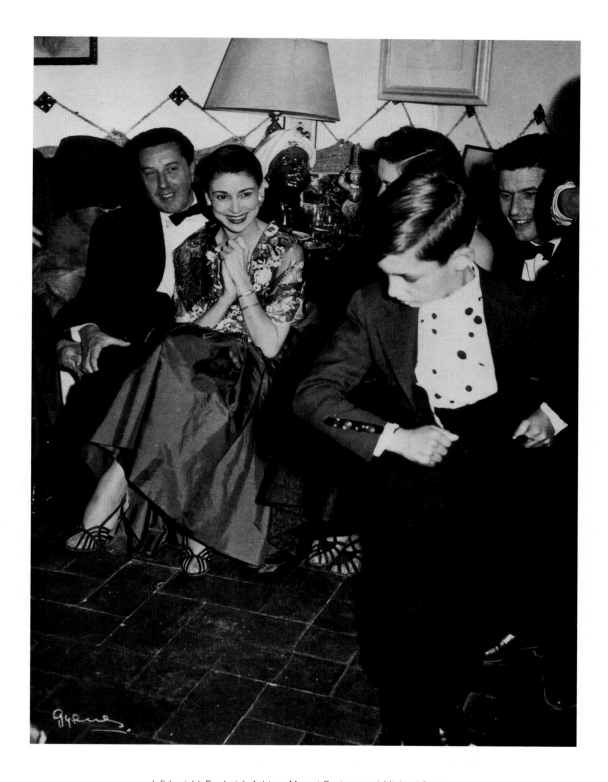

left to right: Frederick Ashton, Margot Fonteyn and Michael Somes,
watching a young Flamenco dancer during the Granada Festival, June 1953

ONDINE

The role of the water sprite Ondine in the ballet of that name was created for Fonteyn in 1958 and at its heart is the love of the sea and water, which she and Ashton shared. Ashton described how he spent many hours watching water move and how he tried to give the choreography the surge and swell of the waves. The role became so closely associated with Fonteyn that when she stopped dancing it, the ballet disappeared from the repertory. Anthony Dowell as Director of The Royal Ballet persuaded Ashton to allow the Company to revive it in 1988. Christopher Newton produced the revival with Maria Almeida as Ondine and Dowell as Palemon. Julia Farron danced Berta as she had in the original 1958 production!

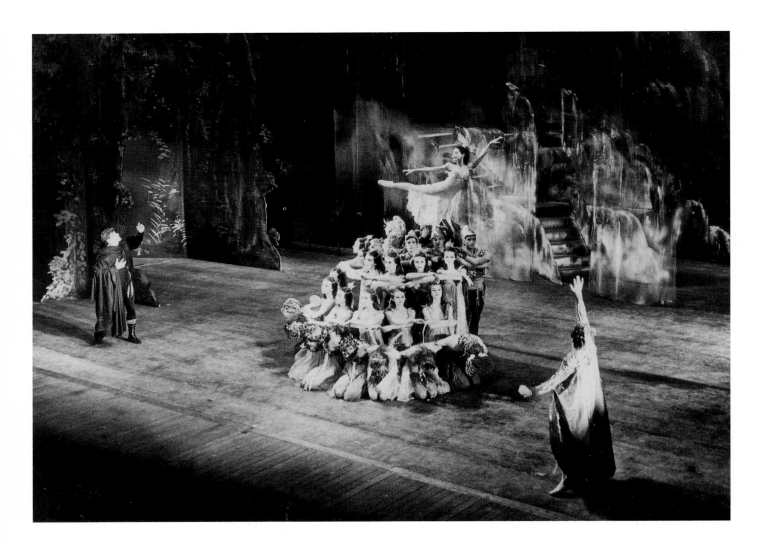

Michael Somes as Palemon, Margot Fonteyn as Ondine,
Alexander Grant as Tirrenio with Artists of The Royal Ballet in
Ondine, 1958

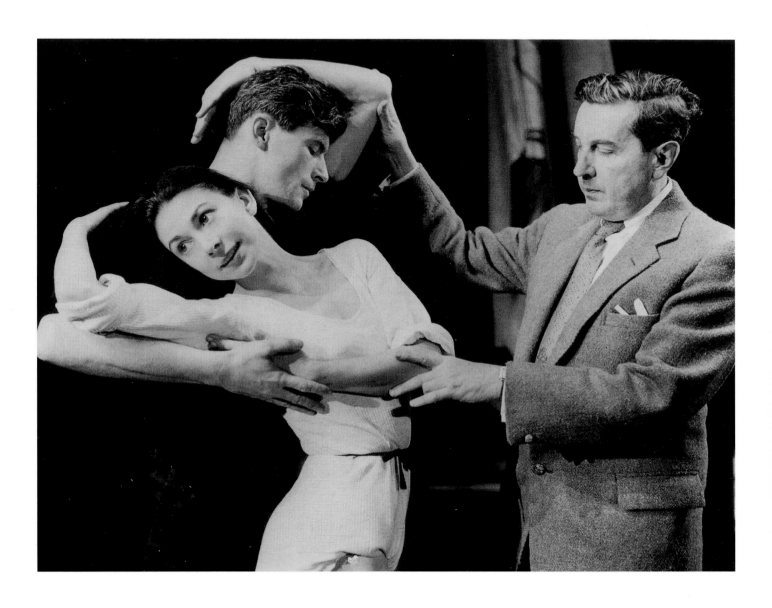

Margot Fonteyn, Michael Somes and Frederick Ashton in rehearsal for
Ondine, 1958

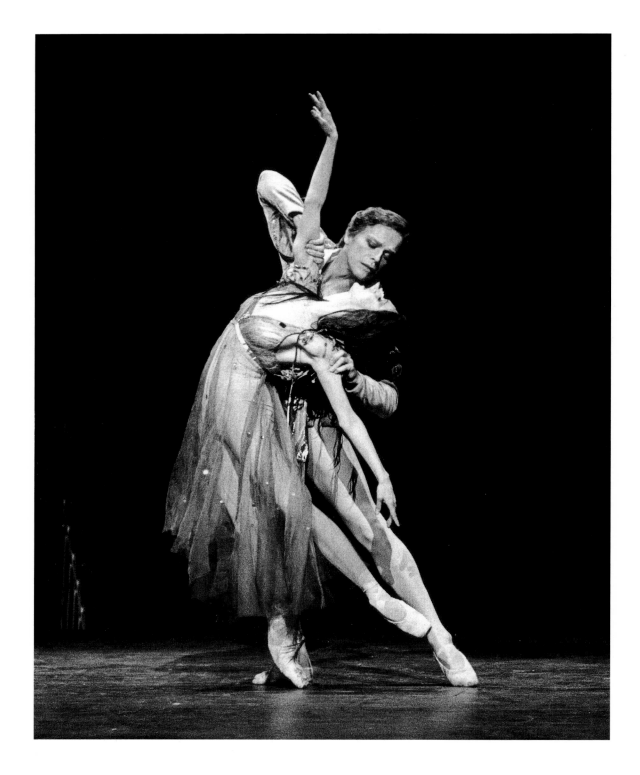

Maria Almeida as Ondine, Anthony Dowell as Palemon in
Ondine, 1988

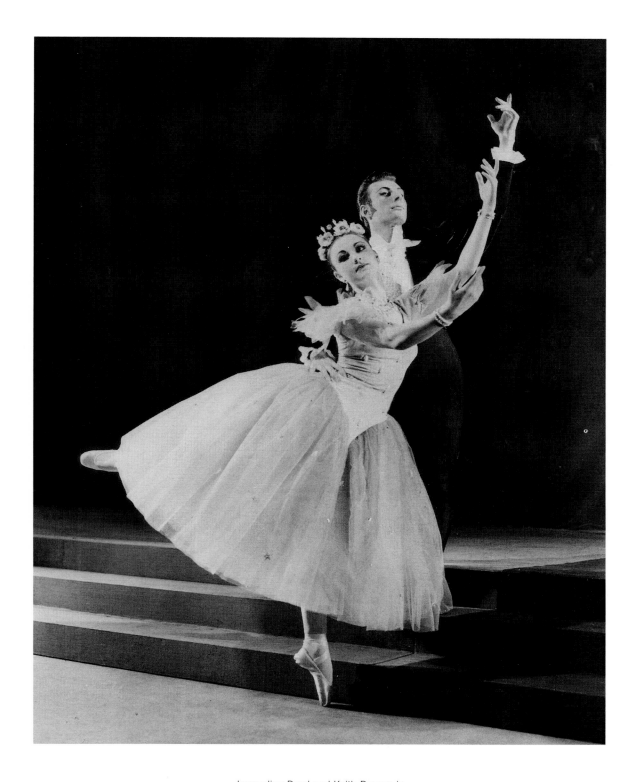

Jacqueline Daryl and Keith Rosson in
La Valse, 1959

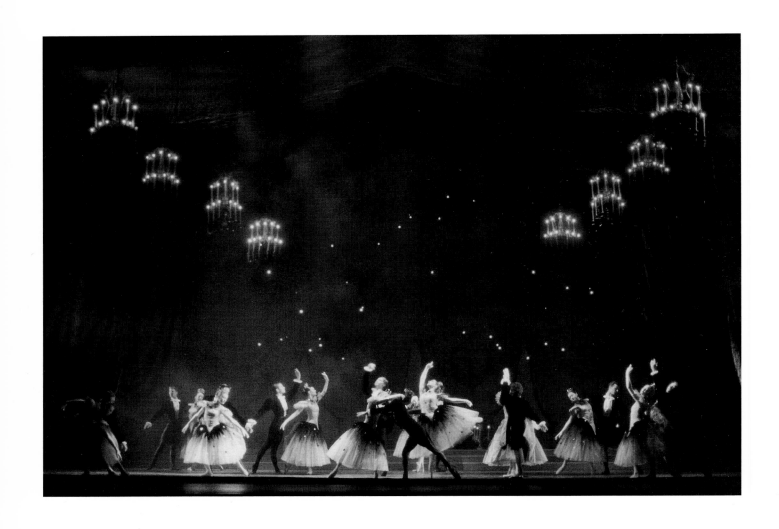

The Royal Ballet in
La Valse, 2000

LA FILLE MAL GARDÉE

It was Tamara Karsavina who suggested to Ashton that he should create a new version of *La Fille mal gardée*. She had danced in the Petipa/Ivanov production in Russia and taught Ashton details she remembered such as Lise's mime scene from the second act. It is one of his masterpieces; a sunny, comic ballet which gladdens the heart. The ballet tells of the earthly love of Lise and Colas and how they triumph over Lise's mother's attempts to marry Lise off to a wealthy suitor. Ashton created Lise and Colas on Nadia Nerina and David Blair and their technical accomplishments gave him the opportunity to create some of his most demanding *pas de deux* and variations. He was also able to exploit the glorious comic talents of Stanley Holden as Widow Simone, Alexander Grant as Alain and Leslie Edwards as Thomas. Amazing play with pink ribbons, beautiful *pas de deux* and inventive choreography for the *corps de ballet*, the ballet is also Ashton's hymn to late spring in his beloved Suffolk countryside and draws on a range of English traditions including music hall, pantomime, Lancashire clog dancing and country May-time festivities.

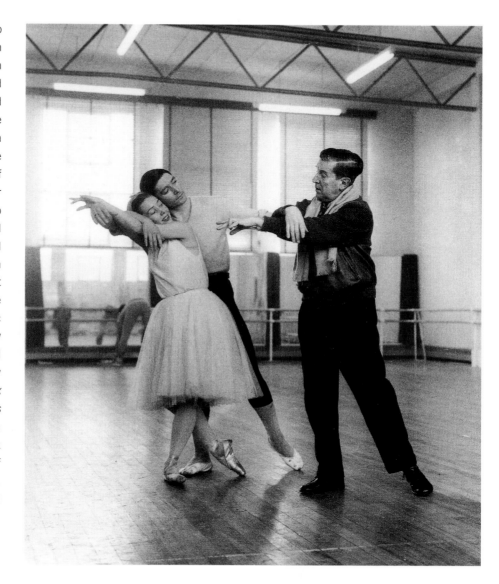

Frederick Ashton rehearsing Nadia Nerina as Lise and David Blair as Colas
in the final *pas de deux* from *La Fille mal gardée*, 1960

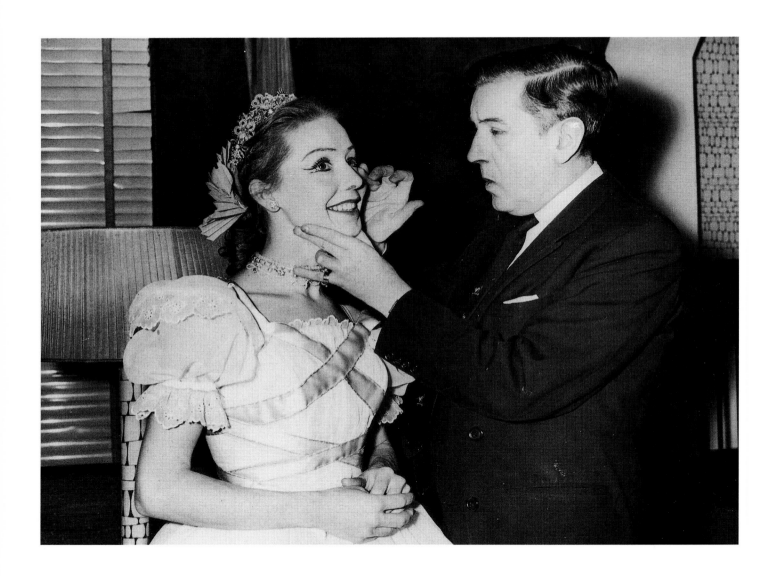

Frederick Ashton checks Nadia Nerina's make up before a performance of
La Fille mal gardée, 1960

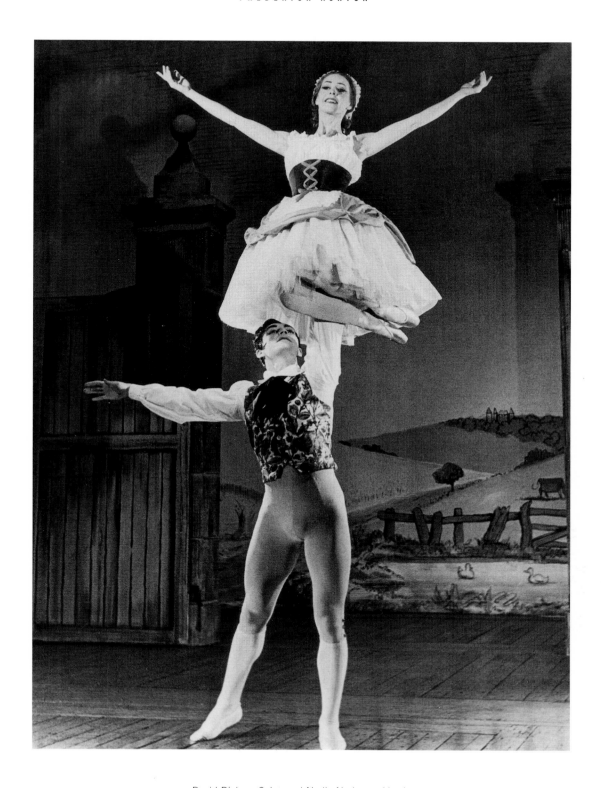

David Blair as Colas and Nadia Nerina as Lise in
La Fille mal gardée, 1960

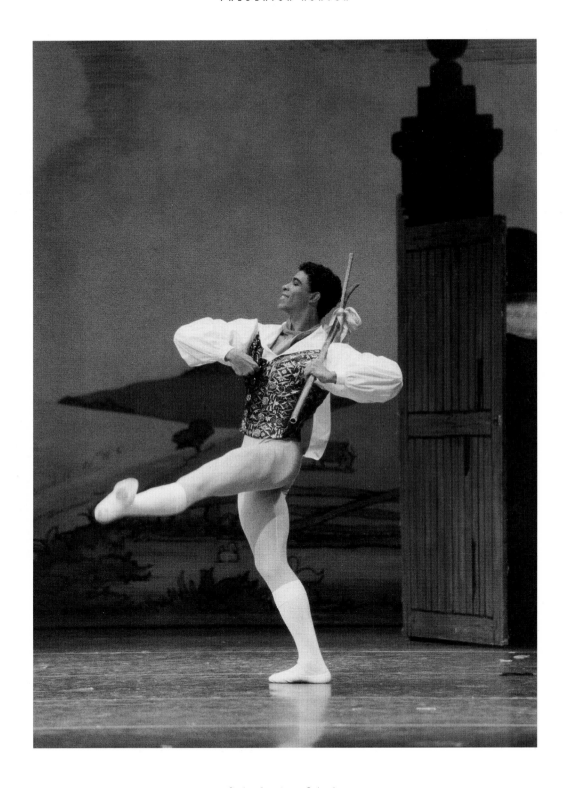

Carlos Acosta as Colas in
La Fille mal gardée, 2001

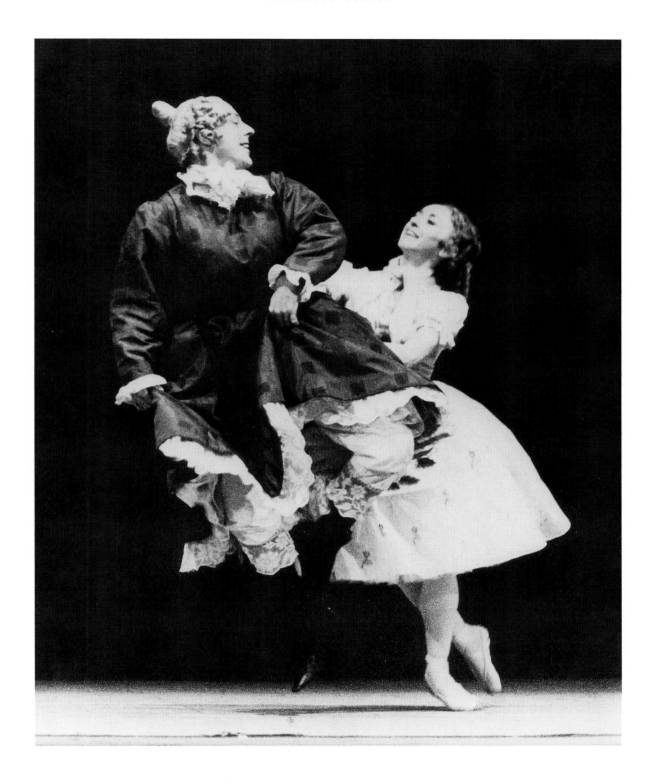

Brian Shaw as Widow Simone and Brenda Last as Lise in
La Fille mal gardée, 1966

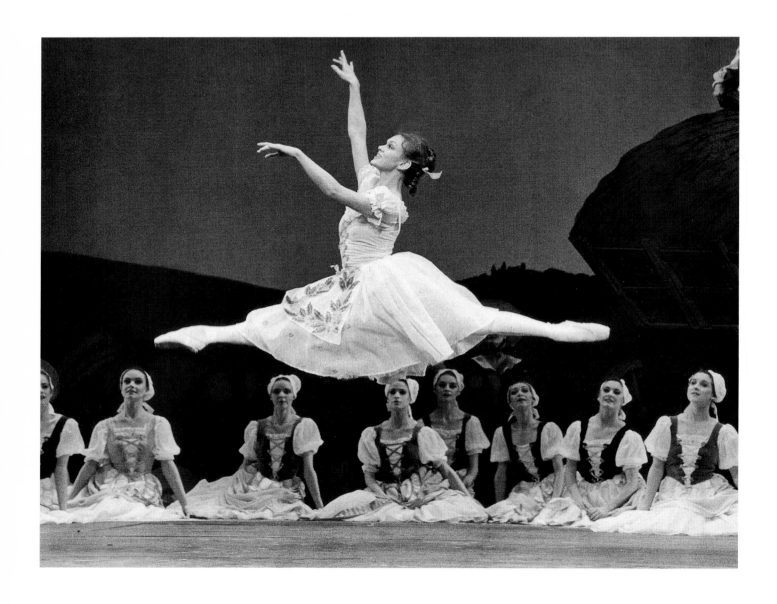

Lesley Collier as Lise,
La Fille mal gardée, 1971

Lesley Collier coaching Marianela Nuñez in the role of Lise,
La Fille mal gardée, 2004

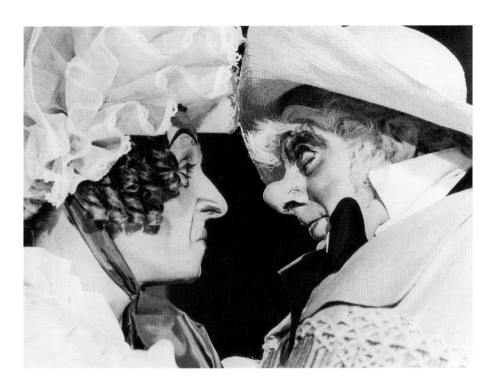

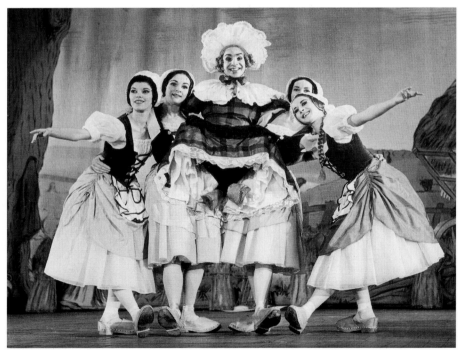

above: Stanley Holden as Widow Simone and Leslie Edwards as Thomas, 1960
below: Ronald Emblen as Widow Simone with Artists of The Royal Ballet, 1962
in *La Fille mal gardée*

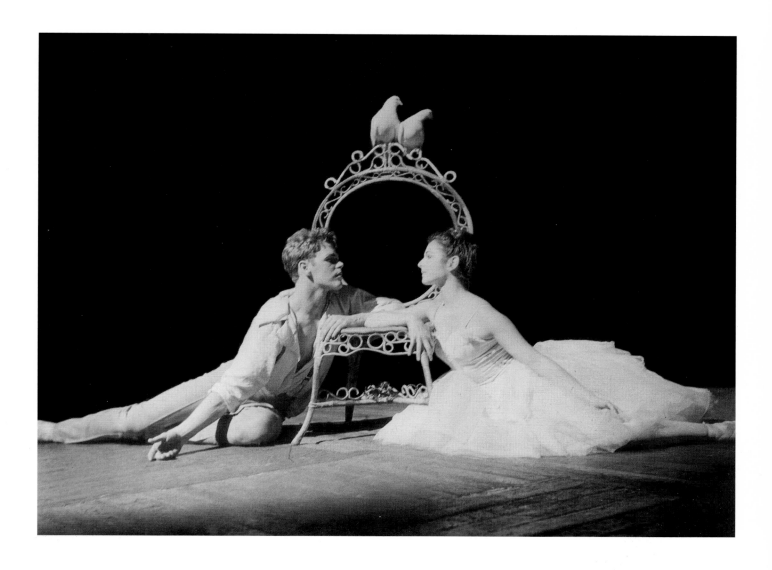

Christopher Gable as The Young Man and Lynn Seymour as The Young Girl
in *Les Deux pigeons*, 1961,
known as *The Two Pigeons* from 16 October 1962

ONE-ACT MASTERWORKS

The later part of Ashton's career saw him taking the one-act ballet form and using it to create a series of masterworks, in which he distilled perfect evocations of his subject matter.

Marguerite and Armand

Rudolf Nureyev was the first high-profile ballet dancer to defect to the West in Paris in 1961 and later that year Margot Fonteyn invited him to dance in London at the Royal Academy of Dancing Gala she was organising. Nureyev agreed but asked that Ashton create a solo for him. The solo *Poème tragique* was only seen on that one occasion but perfectly encapsulated this extraordinary moment in ballet history. De Valois realised that she must bring Nureyev to The Royal Ballet and invited him to dance *Giselle* with Fonteyn. Two weeks before their first appearance together at the Royal Opera House on 21 February 1962 Frederick Ashton commented that, 'It could be that the appearance of Margot Fonteyn and Rudolf Nureyev in *Giselle* will cause as big a stir as the performances of Pavlova and Nijinsky in the same ballet.' Events were to prove him right. In 1963, Ashton put his mark on this great partnership by creating *Marguerite and Armand* for them. The role of Marguerite gave full rein to Fonteyn's extraordinary dramatic abilities while Armand drew on Nureyev's passionate ardour. A gloriously romantic work, it is fitting that while Fonteyn and Nureyev lived, no other dancers performed it.

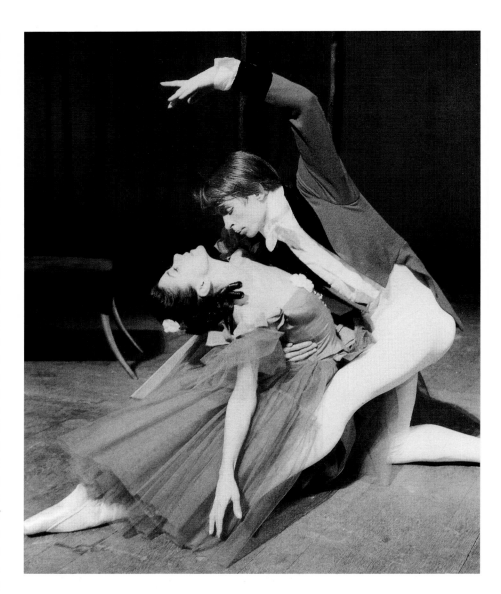

Margot Fonteyn as Marguerite
and Rudolf Nureyev as Armand in
Marguerite and Armand, 1963

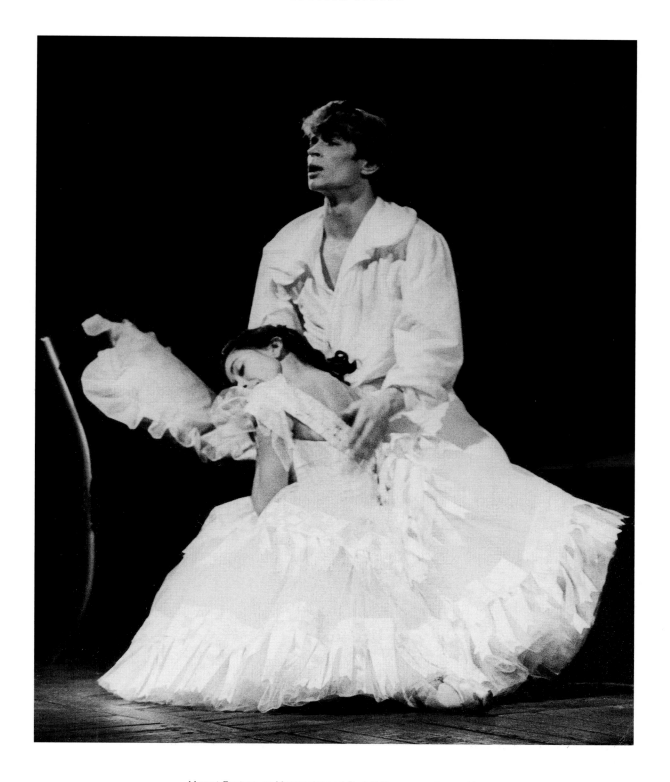

Margot Fonteyn as Marguerite and Rudolf Nureyev as Armand in
Marguerite and Armand, 1963

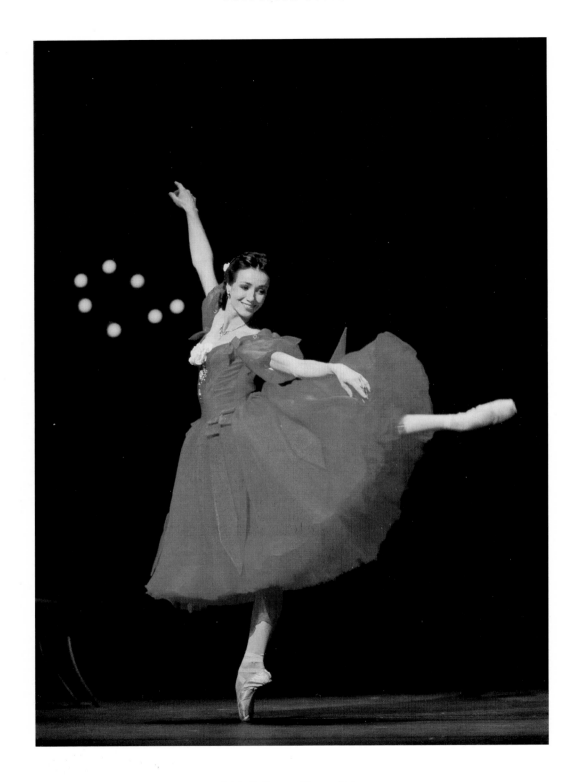

Sylvie Guillem as Marguerite in
Marguerite and Armand, 2002

THE DREAM

Ashton created *The Dream*, based on Shakespeare's *A Midsummer Night's Dream*, to celebrate the quatercentenary of Shakespeare's birth in 1964. John Lanchbery prepared a score from Mendelssohn's music, Henry Bardon designed the set and David Walker the costumes. *The Dream* was to be the beginning of a legendary partnership. Ashton, with great perspicacity, chose two young dancers, Antoinette Sibley and Anthony Dowell, to dance Titania and Oberon. Sibley was a rising young ballerina and Dowell was beginning to dance solos although still in the *corps de ballet*. *The Dream*, like many of Ashton's works, was not critically well received at first, but it has come to be regarded as one of his masterpieces. David Vaughan has called it 'another of the great ballets of his maturity on the subject of human nature'.

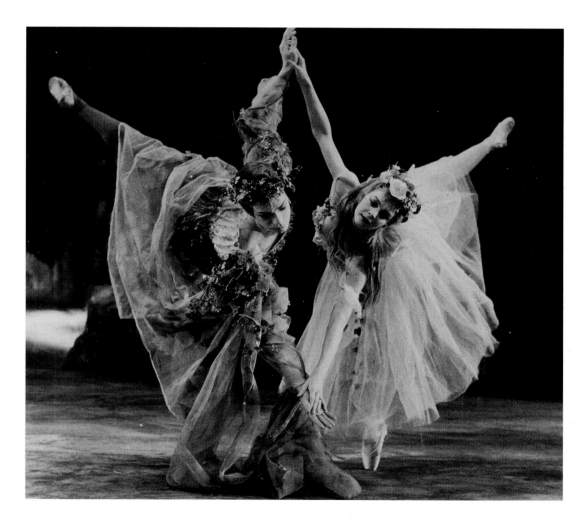

Anthony Dowell as Oberon and Antoinette Sibley as Titania in
The Dream, 1964

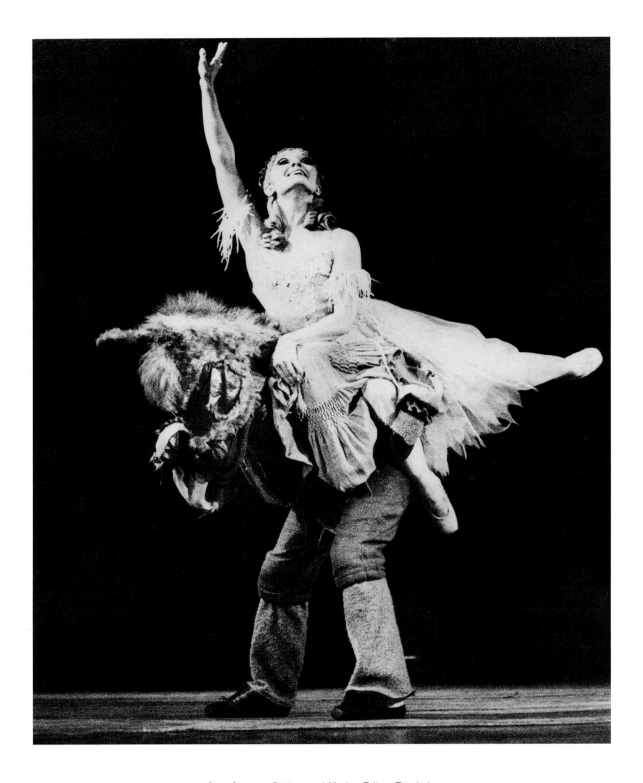

Gary Grant as Bottom and Marion Tait as Titania in
The Dream, 1975

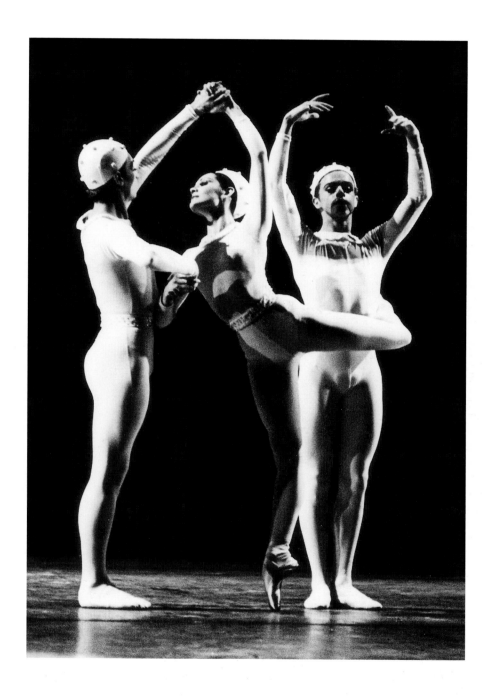

left to right: Robert Mead, Vyvyan Lorrayne
and Anthony Dowell in *Monotones*, 1965

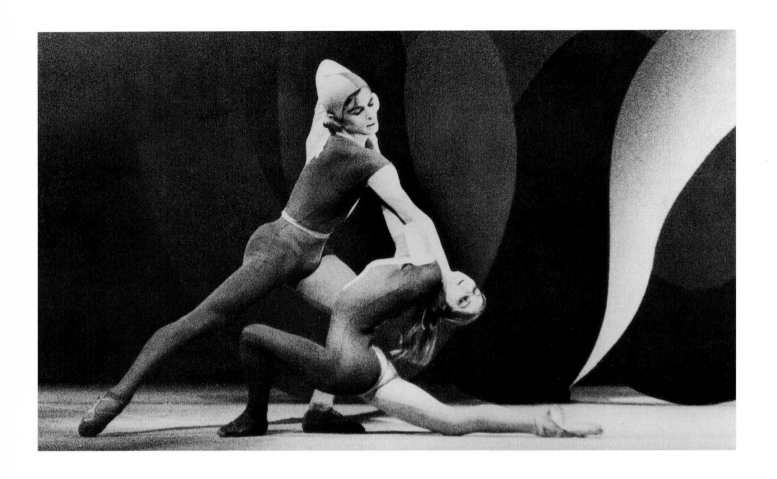

Rudolf Nureyev and Antoinette Sibley as Friday in
Jazz Calendar, 1968

THE DIAGHILEV INHERITANCE

Frederick Ashton became Director of The Royal Ballet in 1963 and as Director he took the opportunity to invite Bronislava Nijinska to stage two of her great ballets for the Company: *Les Biches* in 1964 and *Les Noces* in 1966. Nijinska's ballets had fallen somewhat into obscurity and Ashton's actions were responsible for ensuring a proper reassessment of her work, thus restoring them to their rightful place as seminal works of the twentieth century. Ashton often claimed that *Les Noces* was his favourite ballet and said, 'When I saw *Les Noces*, I realized what a great choreographic genius Nijinska was.'

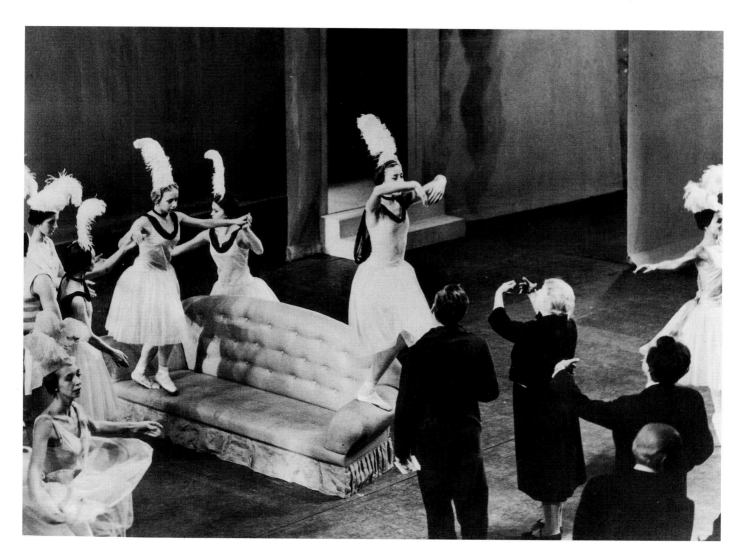

Bronislava Nijinska rehearsing Artists of The Royal Ballet in
Les Biches, 1964

left to right: Bronislava Nijinska,
David Blair, Frederick Ashton and Georgina Parkinson
during a rehearsal of *Les Biches*, 1964

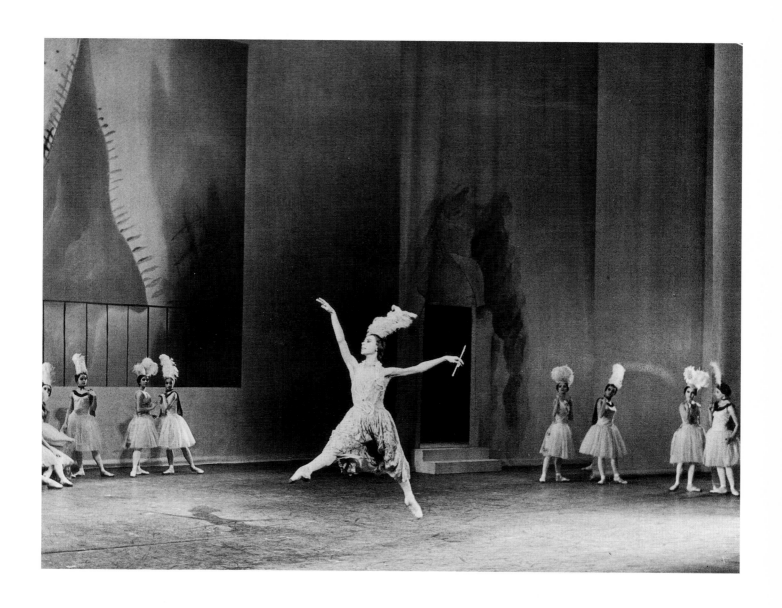

Svetlana Beriosova and Artists of The Royal Ballet in
Les Biches, 1964

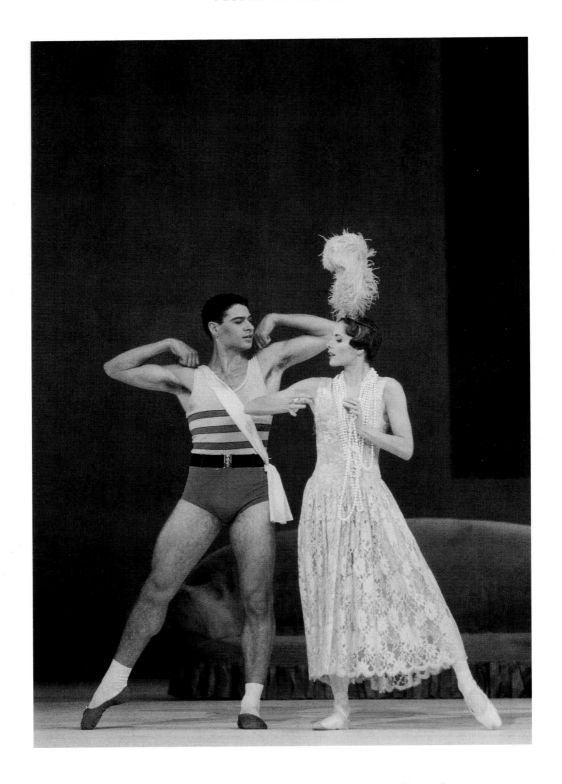

Inaki Urlezaga as Rag Mazurka Boy and Darcey Bussell as the Hostess in
Les Biches, 2000

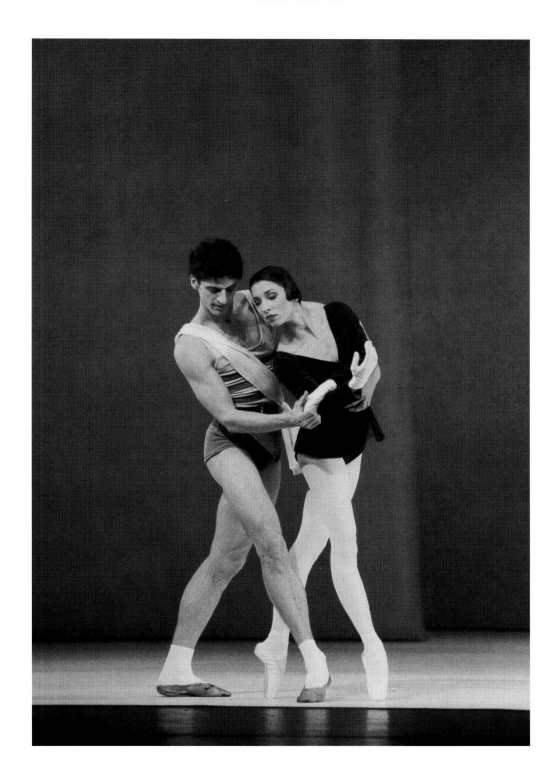

Jonathan Cope as Centre Man and Mara Galeazzi as Blue Girl in
Les Biches, 2000

Bronislava Nijinska and Frederick Ashton during rehearsals for
Les Noces, 1966

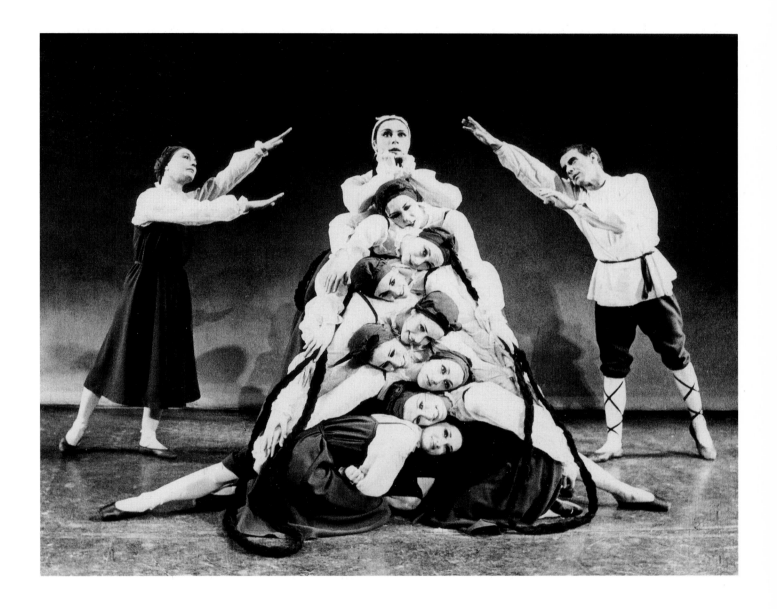

Gerd Larsen as The Mother, Svetlana Beriosova as The Bride and Ray Roberts as The Father
with Artists of The Royal Ballet in *Les Noces*, 1966

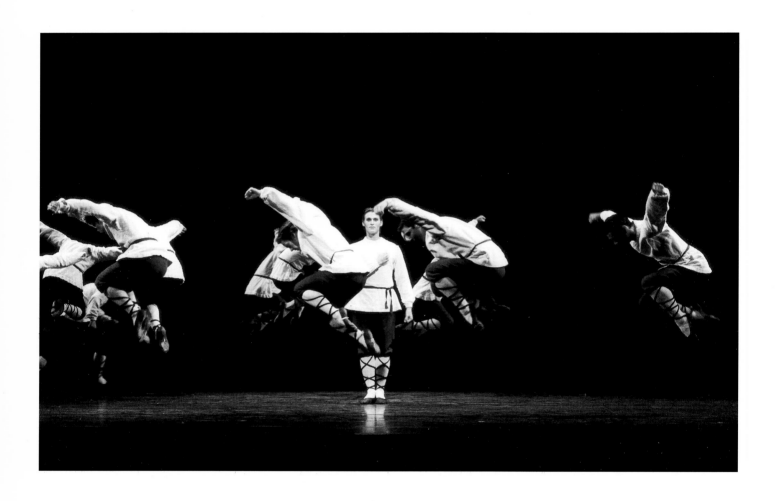

David Pickering as The Bridegroom with Artists of The Royal Ballet in
Les Noces, 2001

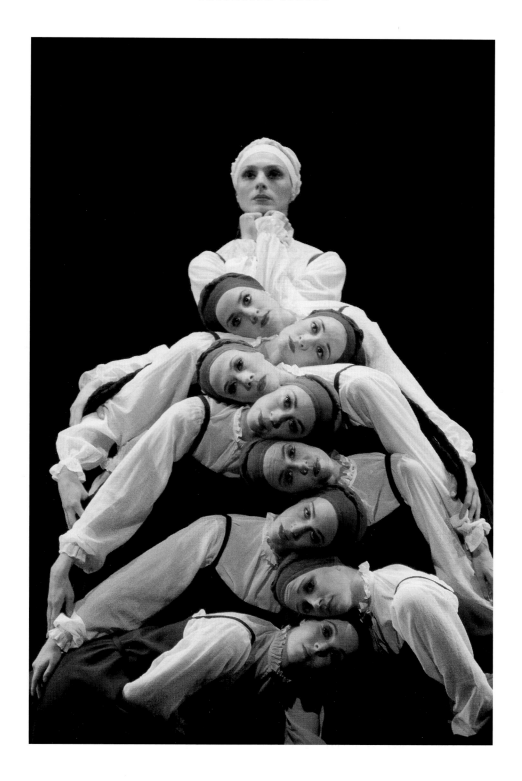

Zenaida Yanowsky as The Bride with Artists of The Royal Ballet in
Les Noces, 2001

ENIGMA VARIATIONS AND A MONTH IN THE COUNTRY

In the early 1950s, a stage design student Julia Trevelyan Oman left a portfolio of designs for a ballet on Elgar at the stage door. It was not until 1966 that she received a telephone call from Frederick Ashton saying he remembered her designs and that he thought the time was now right for such a ballet. Elgar's music, Ashton's choreography and Trevelyan Oman's designs combined to create a masterpiece:

the elegiac *Enigma Variations* captures the mood of a lost world, an Edwardian, English country summer as successfully as it conveys the characters and relationships of Elgar's circle. In The Lady, Elgar's Wife, Ashton gave Svetlana Beriosova perhaps her greatest role.

While working on *Enigma Variations*, Ashton mentioned to Trevelyan Oman, seen below

on the right, that he was thinking of making a ballet based on Turgenev's play *A Month in the Country* and that he wanted her to design it. It was another ten years before the project came to fruition. Ashton finally settled on early Chopin pieces for the score, after having been lent some records by Michael Somes. Ashton chose to create the role of Natalia Petrovna on Lynn Seymour, then at the height of her powers as a dazzling dance actor.

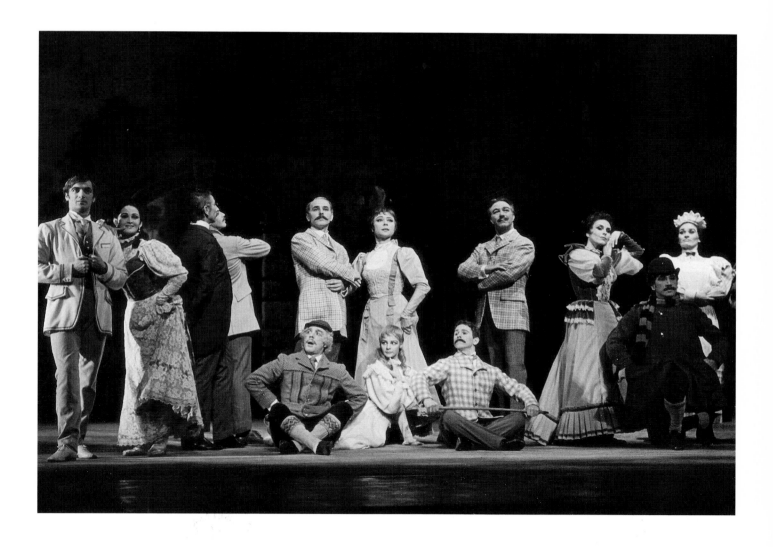

standing left to right: Robert Mead as Richard P Arnold, Vyvyan Lorrayne as Isabel Fitton, Desmond Doyle as A J Jaeger, Anthony Dowell as Arthur Troyte Griffith, Derek Rencher as Edward Elgar, Svetlana Beriosova as The Lady, Elgar's Wife, Leslie Edwards as Basil G Nevinson, Georgina Parkinson as Winifred Norbury, Julie Wood as the Housekeeper
sitting left to right: Brian Shaw as Baxter Townsend, Antoinette Sibley as Dora Penny, Wayne Sleep as George Robertson Sinclair and Alexander Grant as William Meath Baker in *Enigma Variations*, 1968

Detail from set design by Julia Trevelyan Oman

A Month in the Country

Ballet in one act
Freely adapted from Turgenev's play

Choreography by FREDERICK ASHTON

Music by FREDERICK CHOPIN (1810–1849)

Arranged by JOHN LANCHBERY

Scenery and costumes by JULIA TREVELYAN OMAN

Lighting by WILLIAM BUNDY

NATALIA PETROVNA	LYNN SEYMOUR
YSLAEV, *her husband*	ALEXANDER GRANT
KOLIA, *their son*	WAYNE SLEEP
VERA, *Natalia's ward*	DENISE NUNN
RAKITIN, *Natalia's admirer*	DEREK RENCHER
KATIA, *a maid*	MARGUERITE PORTER
MATVEI, *a footman*	ANTHONY CONWAY
BELIAEV, *Kolia's Tutor*	ANTHONY DOWELL

Solo Pianist PHILIP GAMMON
Conductor JOHN LANCHBERY

The action takes place at Yslaev's country house in 1850. Beliaev, a young student, engaged as a tutor for Kolia, disrupts the emotional stability of the household. Finally Rakitin, Natalia's admirer, insists that he and the tutor must both leave in order to restore a semblance of calm to Yslaev's family life.

A Month in the Country is dedicated to the memory of Sophie Fedorovitch and Bronislava Nijinska, Chopin's compatriots and my mentors.

My thanks are due to Sir Isaiah Berlin, O.M. for suggesting that Chopin was the right composer for Turgenev; to Michael Somes, C.B.E. who brought the music used in the ballet to my notice; to Martyn Thomas who helped me construct the action of the ballet to accord with the music.
F. A. 1976

Scenery built by Tom Walker
Scenery painted by Peter Courtier & Robin Snow
Props made by Michael Whiteley
Costumes made by Winifred Clay, Sergio Piatto & Alan Huntington
Jewellery by Jean Percival
Wigs by Ronald Freeman
Fabric dyeing by Valerie Connell
} COVENT GARDEN PRODUCTION DEPARTMENT

Shoes by Anello & Davide, Frederick Freed, Gamba and Porselli
Programme photograph of Frederick Ashton by Zoë Dominic

Interval: *approximately 20 minutes. Warning bells will be sounded five minutes and two minutes before the rise of the curtain*

Programme extract for *A Month in the Country*, 1976

Wig designs by
Julia Trevelyan Oman for
A Month in the Country

(top) Natalia/Lynn Seymour
(centre) Beliaev/Anthony Dowell, Yslaev/Alexander Grant,
Rakitin/Derek Rencher
(bottom) Kolia/Wayne Sleep, Katia/Marguerite Porter,
Vera/Denise Nunn

Wig designs by Julia Trevelyan Oman for *A Month in the Country, above:* Lynn Seymour as Natalia
middle: Anthony Dowell as Beliaev, Alexander Grant as Yslaev, Derek Rencher as Rakitin
below: Wayne Sleep as Kolia, Marguerite Porter as Katia, Denise Nunn as Vera

Frederick Ashton with Lynn Seymour as Natalia Petrovna, Anthony Dowell
as Beliaev in rehearsal for *A Month in the Country*, 1976

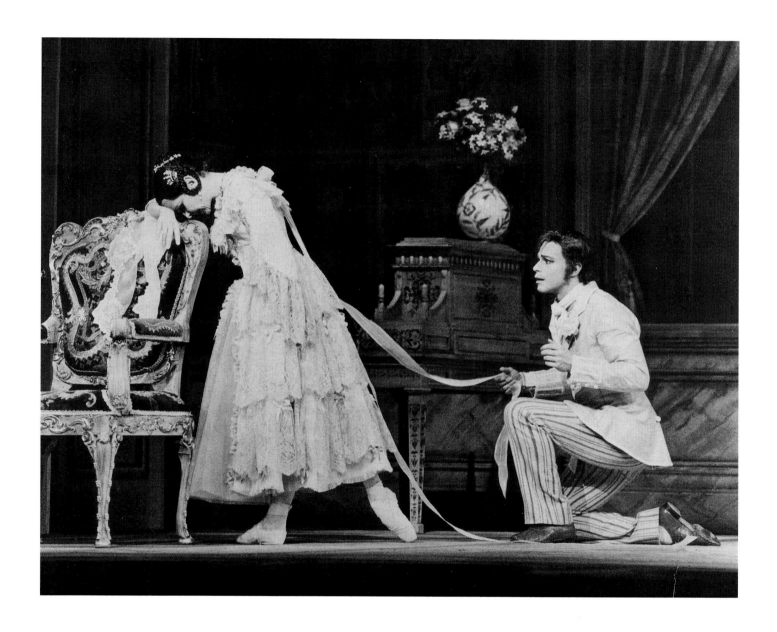

Lynn Seymour as Natalia Petrovna and Anthony Dowell as Beliaev in
A Month in the Country, 1976

THE TALES OF BEATRIX POTTER

In 1970, Ashton worked on the film *The Tales of Beatrix Potter*, produced by Richard Goodwin, directed by Reginald Mills and designed by Christine Edzard. John Lanchbery produced a score based on Victorian and Edwardian salon and theatre music. The film was danced by members of the two Royal Ballet Companies with Ashton himself as Mrs Tiggy-Winkle. Like Beatrix Potter's stories and illustrations, the ballet is firmly rooted in English country life and has been the means of introducing a whole new audience to dance. In 1992, Anthony Dowell, then Director of The Royal Ballet, produced a stage version of *The Tales of Beatrix Potter* for The Royal Ballet.

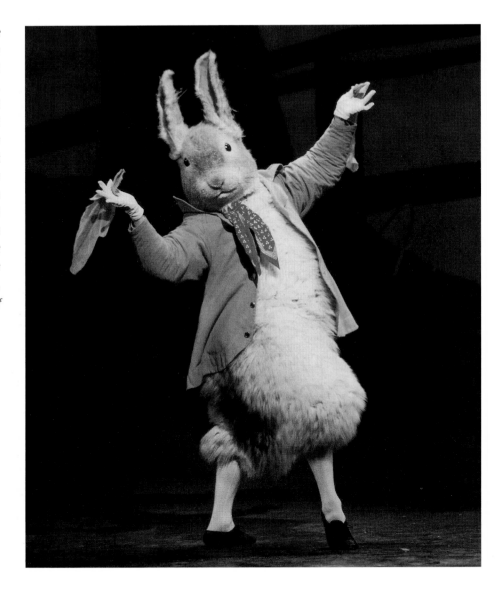

Ashley Page as Peter Rabbit in
The Tales of Beatrix Potter, 1992

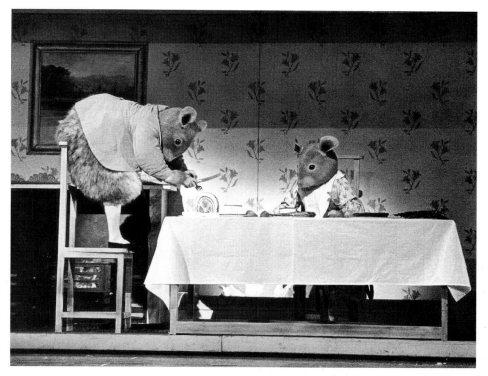

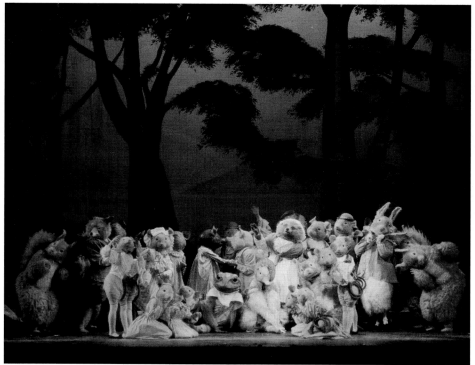

above: Jonathan Howells as Tom Thumb and Nicola Roberts as Hunca Munca
below: Final tableau from
The Tales of Beatrix Potter, 1992

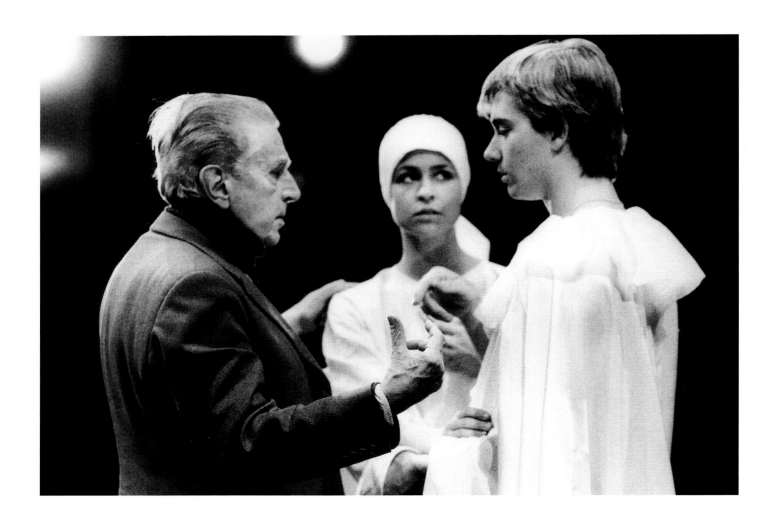

Frederick Ashton, Christina Parker and Mark Freeman during a rehearsal of
Illuminations, 1981

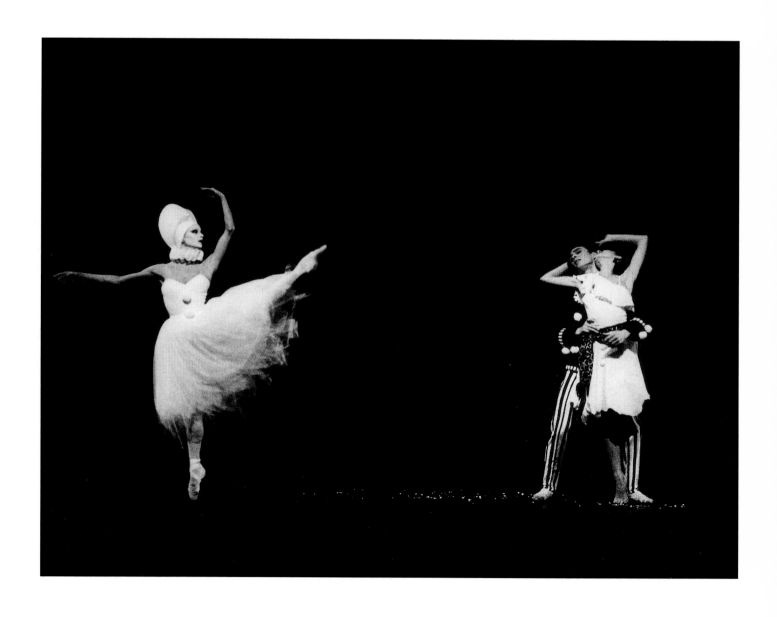

left to right: Jennifer Penney as Sacred Love, Ashley Page as the Poet
and Genesia Rosato as Profane Love in *Illuminations*, 1981

GALAS AND CELEBRATIONS

Anniversaries and important events in the history of The Royal Ballet have been marked by Galas and Special Performances. Frederick Ashton created several short pieces for these occasions as well as appearing himself. Many were attended by HRH The Princess Margaret, Patron of The Royal Ballet, as well as by Her Majesty The Queen Mother, both of whom were great supporters of The Royal Ballet as well as personal friends of Ashton.

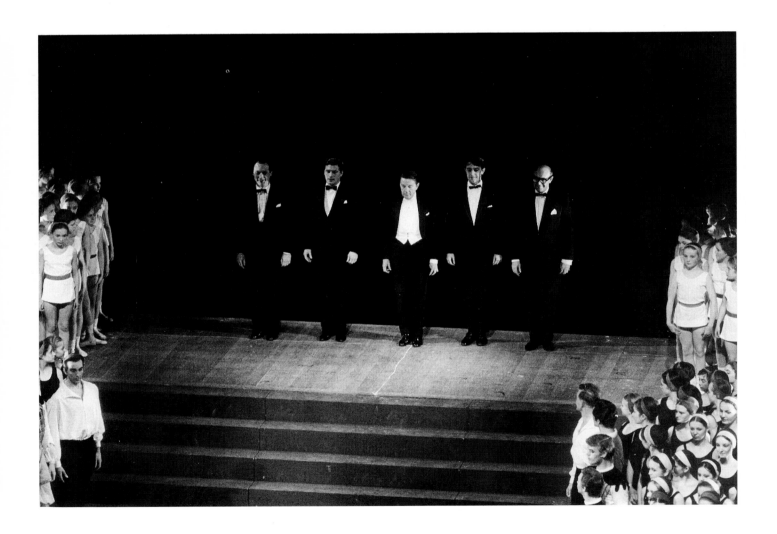

left to right: John Hart, Michael Somes, Frederick Ashton,
Kenneth MacMillan and John Field in the *Grand defilé* at the Farewell Gala for
Ninette de Valois, 7 May 1964

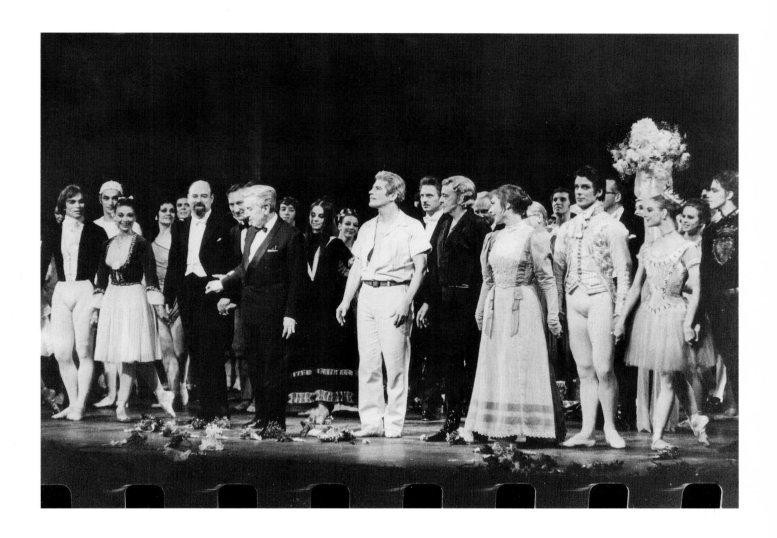

Tribute to Sir Frederick Ashton, 24 July 1970, the Gala at the Royal Opera House to mark his retirement as Director of The Royal Ballet.
The Gala included extracts from 35 of his ballets and a complete performance of *Symphonic Variations*.
from left to right: Rudolf Nureyev as Armand, Margot Fonteyn as Chloë, Conductor John Lanchbery, John Hart, Frederick Ashton,
Michael Somes as Daphnis, Robert Helpmann, Svetlana Beriosova as The Lady, Elgar's Wife, Donald MacLeary as The Prince in *Cinderella*,
Antoinette Sibley as Aurora and Anthony Dowell as Prince Florimund in *The Sleeping Beauty*

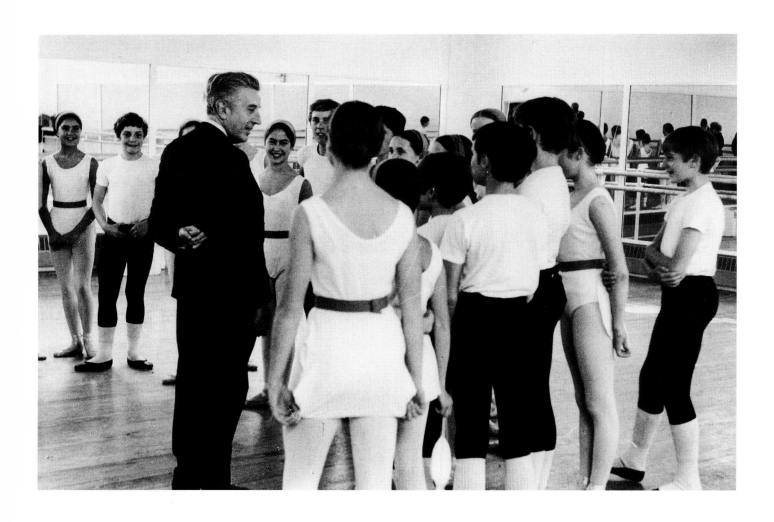

Frederick Ashton with students of The Royal Ballet School at White Lodge
in the newly named Ashton Studio, June 1970

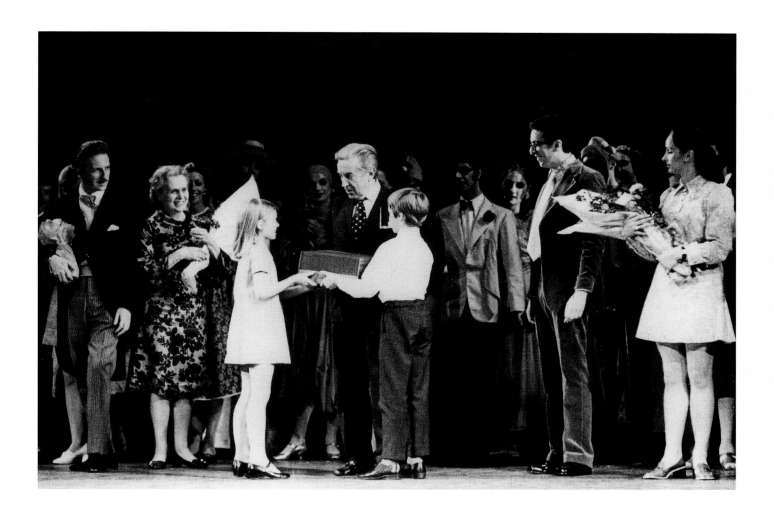

Frederick Ashton being presented with a retirement present of a record player by students
after The Royal Ballet School matinée performance, 13 June 1970

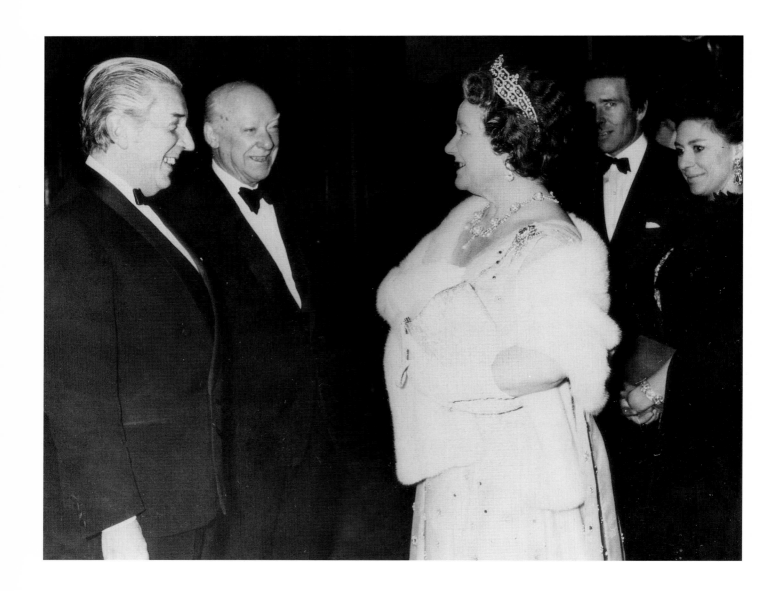

left to right: Frederick Ashton, David Webster, General Administrator of the Royal Opera House,
Her Majesty Queen Elizabeth The Queen Mother, Lord Snowdon, HRH The Princess Margaret
at the Gala *Tribute to Sir Frederick Ashton*, 24 July 1970

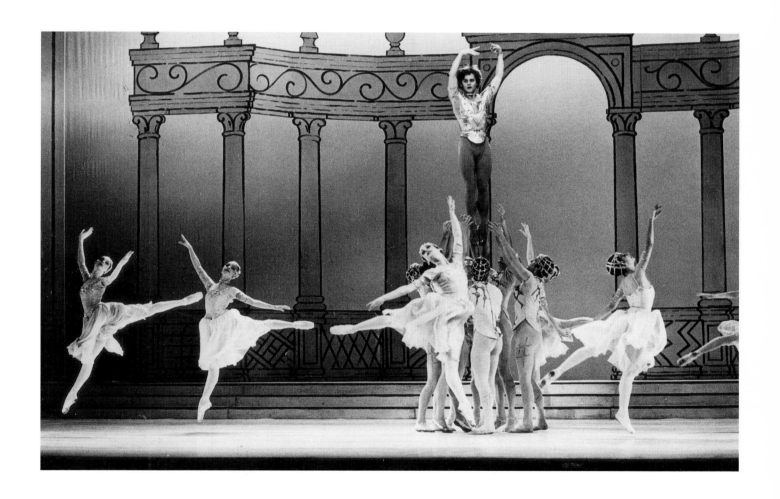

Mikhail Baryshnikov, with Artists of The Royal Ballet in *Rhapsody,* created by Ashton to celebrate the
eightieth birthday of Her Majesty Queen Elizabeth The Queen Mother, 4 August 1980

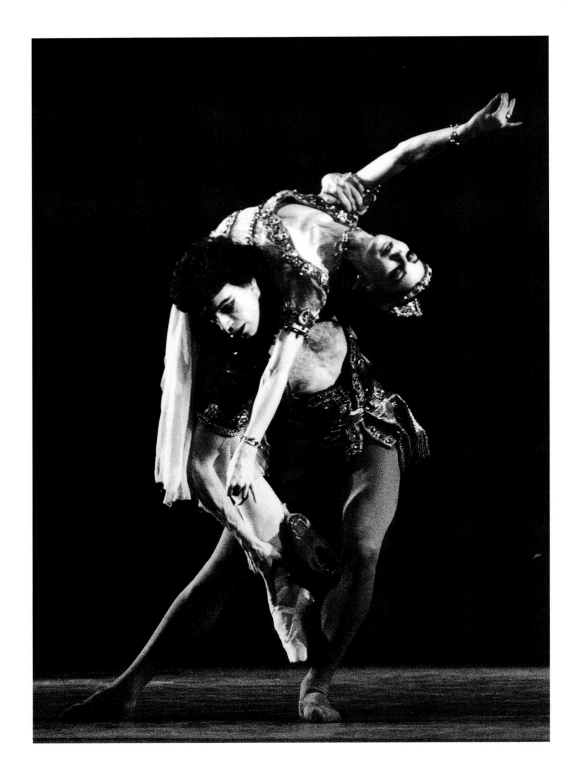

Antoinette Sibley and Anthony Dowell in
Meditation from Thaïs, 1971

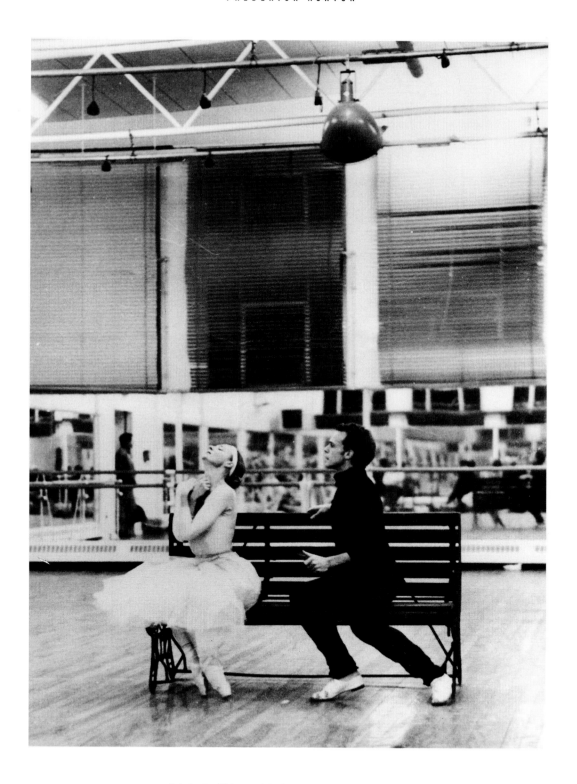

Antoinette Sibley and Anthony Dowell in rehearsal for
Soupirs, 1980

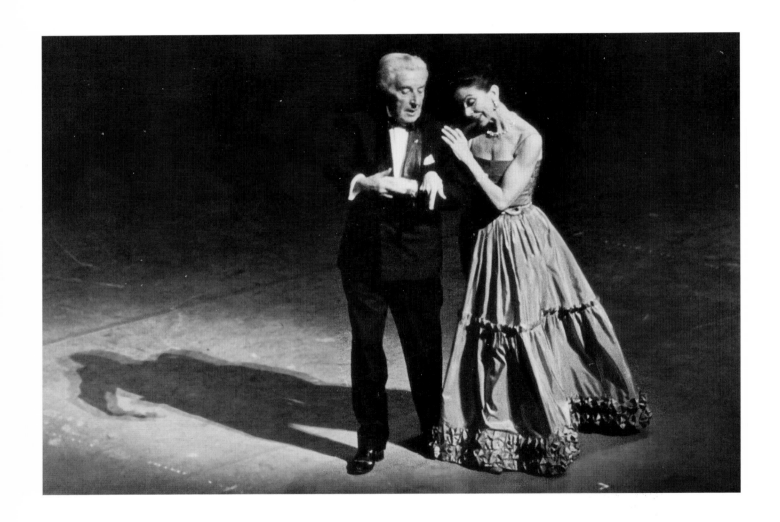

Frederick Ashton and Margot Fonteyn in Ashton's
Salut d'amour à Margot Fonteyn, 23 May 1979

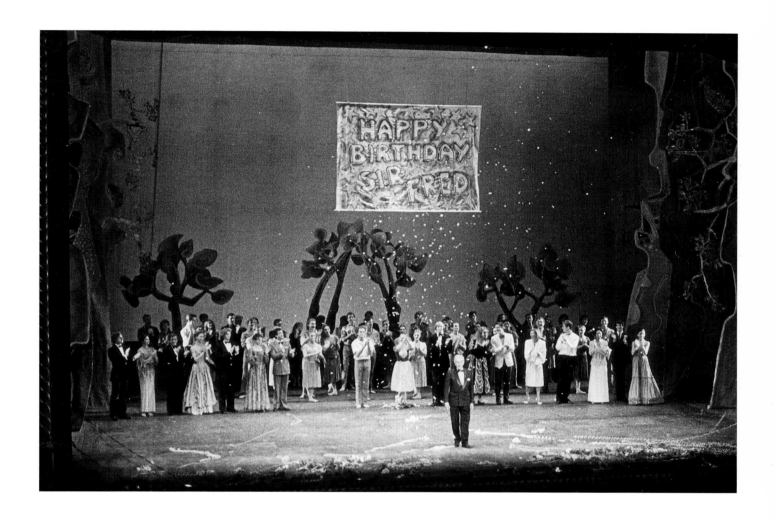

Frederick Ashton on stage after *A Gala Tribute to Sir Frederick Ashton in celebration of his 80th Birthday,* 18 October 1984

left to right: Viviana Durante, Nicola Tranah, Christina Parker, Frederick Ashton,
HRH The Princess Margaret, Mark Freeman, Gail Taphouse and David Peden on stage at the Bloomsbury Theatre
8 December 1985, after Mark Freeman was presented with the Frederick Ashton Choreographic Award

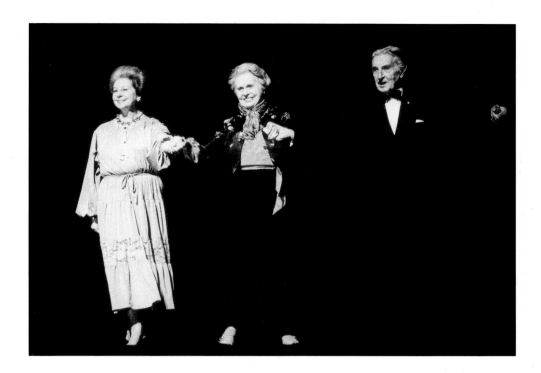

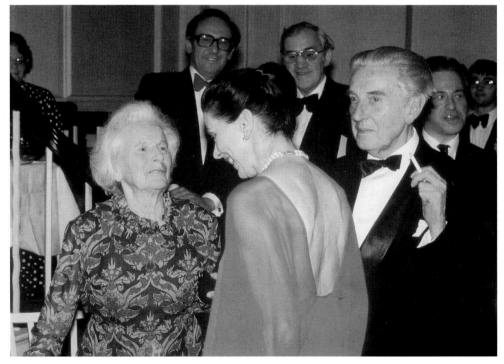

above: Alicia Markova, Ninette de Valois and Frederick Ashton
on stage after the *Save The Wells* Gala at the Royal Opera House, Covent Garden, 1986
below: Marie Rambert, Margot Fonteyn and Frederick Ashton in the Crush Bar at the Royal Opera House,
after *A Gala Tribute to Sir Frederick Ashton*, 18 October 1984

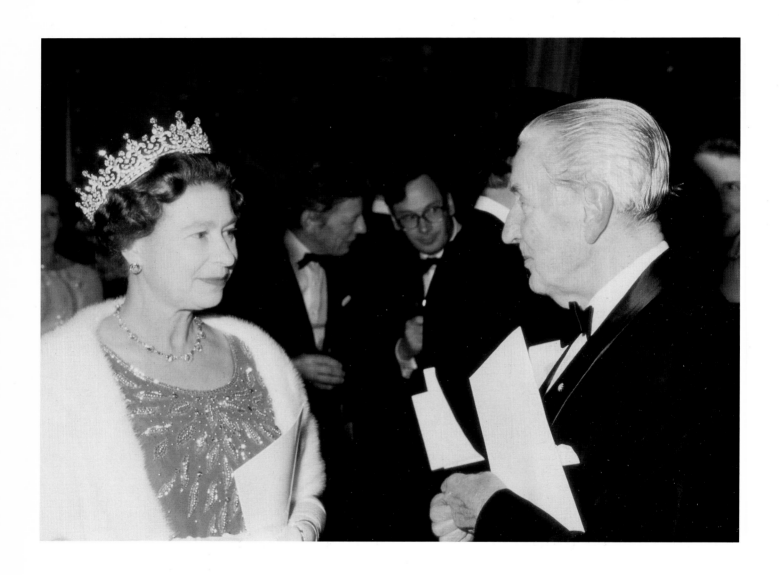

Frederick Ashton and Her Majesty Queen Elizabeth II
at the Gala *Fanfare for Elizabeth* to celebrate Her Majesty The Queen's 60th Birthday,
Royal Opera House, Covent Garden, 21 April 1986

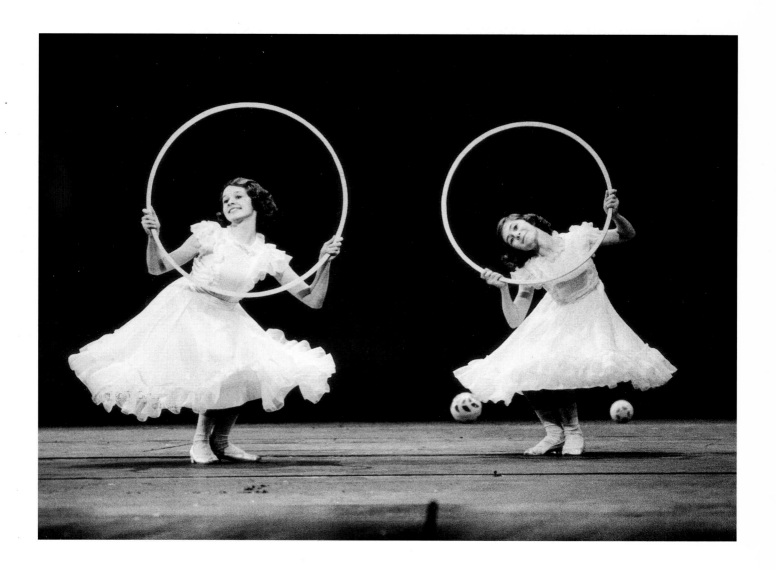

left to right: Zara Deakin and Susannah Jones as The Princess Elizabeth and The Princess Margaret Rose in *Nursery Suite*, the ballet evoking their childhood, created by Ashton for the *Fanfare for Elizabeth* Gala, 1986

A SELECTIVE CHRONOLOGY OF THE BALLETS OF FREDERICK ASHTON

For a full chronology of all Ashton's ballets including details of casts and revivals, see *Frederick Ashton and his Ballets,* by David Vaughan, second edition, 1999, Dance Books, London.

KEY: *(m):* music composed by
(sc): scenery and costumes designed by
(fp): first performance of the ballet

1926
A TRAGEDY OF FASHION *(m):* Eugene Goosens, arranged by Ernest Irving, *(sc):* Sophie Fedorovitch, *(fp):* as part of the revue *Riverside Nights,* Lyric Theatre, Hammersmith, 15 June 1926

1927
SUITE DE DANSES (GALANTERIES) *(m):* Wolfgang Amadeus Mozart, *(fp):* Presentation by Marie Rambert, Imperial Society of Teachers of Dancing Annual Dance Festival, New Scala Theatre 23 July 1927

1930
CAPRIOL SUITE *(m):* Peter Warlock, *(c):* William Chappell, *(fp):* Marie Rambert Dancers, Lyric Theatre, Hammersmith, 25 February 1930. *(fp)* Vic-Wells Ballet: *Pavane* 11 October 1937

1931
LA PÉRI *(m):* Paul Dukas, *(sc):* William Chappell, *(fp):* Ballet Club, 16 February 1931

FAÇADE *(m):* William Walton, *(sc):* John Armstrong, *(fp):* Camargo Society, Cambridge Theatre, 26 April 1931. *(fp)* Vic-Wells Ballet: Sadler's Wells Theatre, 8 October 1935

A DAY IN A SOUTHERN PORT *(m):* Constant Lambert, poem Sacheverell Sitwell, *(sc):* Edward Burra, *(fp):* Camargo Society, Savoy Theatre, 29 November 1931. *(fp)* Vic-Wells Ballet: as *Rio Grande,* Sadler's Wells Theatre, 26 March 1935

1933
LES MASQUES *(m):* Francis Poulenc, *(sc):* Sophie Fedorovitch, *(fp):* Ballet Club, 5 March 1933

LES RENDEZVOUS *(m):* Daniel Francois Auber; arranged by Constant Lambert, *(sc):* William Chappell, *(fp):* Vic-Wells Ballet, Sadler's Wells Theatre, 5 December 1933

1934
MEPHISTO VALSE *(m):* Franz Liszt, *(sc):* Sophie Fedorovitch, *(fp):* Ballet Club, Mercury Theatre, 15 June 1934

LE BAISER DE LA FÉE *(m):* Igor Stravinsky, *(sc):* Sophie Fedorovitch, *(fp):* Vic-Wells Ballet, Sadler's Wells Theatre, 26 November 1935

1936
APPARITIONS *(m):* Franz Liszt, arranged by Constant Lambert, orchestrated by Gordon Jacob, *(sc):* Cecil Beaton, *(fp):* Vic-Wells Ballet, Sadler's Wells Theatre, 11 February 1936

NOCTURNE *(m):* Frederick Delius, *(sc):* Sophie Fedorovitch, *(fp):* Vic-Wells Ballet, Sadler's Wells Theatre, 10 November 1936

1937
LES PATINEURS *(m):* Giacomo Meyerbeer, arranged by Constant Lambert, *(sc):* William Chappell, *(fp):* Vic-Wells Ballet, Sadler's Wells Theatre, 16 February 1937

A WEDDING BOUQUET *(m):* Lord Berners, Libretto: Gertrude Stein, *(sc):* Lord Berners, *(fp):* Vic-Wells Ballet, Sadler's Wells Theatre, 27 April 1937

1939
DEVIL'S HOLIDAY (LE DIABLE S'AMUSE)
(m): Vincenzo Tommasini, on themes by Nicolò Paganini, *(sc):* Eugene Berman, *(fp):* Ballets Russes de Monte Carlo, Metropolitan Opera House, New York, 26 October 1939, *(fp)* The Royal Ballet: *Pas de deux* and solo, Royal Opera House, 13 November, 2004

1940
DANTE SONATA *(m):* Franz Liszt, orchestrated by Constant Lambert, *(sc):* Sophie Fedorovitch, after John Flaxman, *(fp):* Vic-Wells Ballet, Sadler's Wells Theatre, 23 January 1940

1946
SYMPHONIC VARIATIONS *(m):* César Franck, *(sc):* Sophie Fedorovitch, *(fp):* Sadler's Wells Ballet, Royal Opera House, 24 April 1946

LES SIRÈNES *(m):* Lord Berners, orchestrated by Roy Douglas, *(sc):* Cecil Beaton, *(fp):* Sadler's Wells Ballet, Royal Opera House, 12 November 1946

1948
SCÈNES DE BALLET *(m):* Igor Stravinsky, *(sc):* André Beaurepaire, *(fp):* Sadler's Wells Ballet, Royal Opera House, 11 February 1948

CINDERELLA *(m):* Serge Prokofiev, *(sc):* Jean-Denis Malclès, *(fp):* Sadler's Wells Ballet, Royal Opera House, 23 December 1948

1950
ILLUMINATIONS *(m):* Benjamin Britten, Poems by Arthur Rimbaud, *(sc):* Cecil Beaton, *(fp):* New York City Ballet, City Center Theater, New York, 2 March 1950, *(fp)* The Royal Ballet: Royal Opera House, 3 December, 1981

1951
DAPHNIS AND CHLOË *(m):* Maurice Ravel, *(sc):* John Craxton, *(fp):* Sadler's Wells Ballet, Royal Opera House, 3 April 1951

1952
SYLVIA *(m):* Léo Delibes, *(sc):* Robin and Christopher Ironside, *(fp):* Sadler's Wells Ballet, Royal Opera House, 3 September 1952

1953
HOMAGE TO THE QUEEN
The Coronation Ballet (m): Malcolm Arnold, *(sc):* Oliver Messel, *(fp):* Sadler's Wells Ballet, Royal Opera House, 2 June 1953

1956

BIRTHDAY OFFERING *(m):* Alexander Glazunov, arranged by Robert Irving, *(c):* André Levasseur, *(fp):* Sadler's Wells Ballet, Royal Opera House, 5 May 1956

1958

LA VALSE *(m):* Maurice Ravel, *(sc):* André Levasseur, Teatro alla Scala, Milan, 31 January 1958, *(fp):* The Royal Ballet, Royal Opera House, 10 March 1959

ONDINE *(m):* Hans Werner Henze, *(sc):* Lila de Nobili, *(fp):* The Royal Ballet, Royal Opera House, 27 October 1958

1960

LA FILLE MAL GARDÉE *(m):* Ferdinand Herold, arranged by John Lanchbery, *(sc):* Osbert Lancaster, *(fp):* The Royal Ballet, Royal Opera House, 28 January 1960

1961

LES DEUX PIGEONS (THE TWO PIGEONS) *(m):* André Messager, arranged and orchestrated by John Lanchbery, *(sc):* Jacques Dupont, *(fp):* The Royal Ballet Touring Company, Royal Opera House, 14 February 1961

POÈME TRAGIQUE *(m):* Alexander Scriabin, *(c):* William Chappell, *(fp):* Royal Academy of Dancing Gala, Theatre Royal Drury Lane, 2 November 1961

PERSEPHONE *(m):* Igor Stravinsky, *(sc):* Nico Ghika, *(fp):* The Royal Ballet: Royal Opera House, 12 December 1961

1963

MARGUERITE AND ARMAND *(m):* Franz Liszt, orchestrated by Humphrey Searle, *(sc):* Cecil Beaton, *(fp):* The Royal Ballet, Royal Opera House, 12 March 1963

1964

THE DREAM *(m):* Felix Mendelssohn-Bartholdy, arranged by John Lanchbery, *(s):* Henry Bardon, *(c):* David Walker, *(fp):* The Royal Ballet, Royal Opera House, 2 April 1964

1965

MONOTONES *pas de trois (Monotones II)* *(m):* Erik Satie, orchestrated by Claude Debussy and Roland-Manuel, *(c):* Frederick Ashton, *(fp):* The Royal Ballet, Royal Opera House, 24 March 1965
(fp): **MONOTONES I & II** The Royal Ballet, Royal Opera House, 25 April 1965

1968

JAZZ CALENDAR *(m):* Richard Rodney Bennett, *(sc):* Derek Jarman, *(fp):* The Royal Ballet, Royal Opera House, 9 January 1968

ENIGMA VARIATIONS MY FRIENDS PICTURED WITHIN *(m):* Edward Elgar, *(sc):* Julia Trevelyan Oman, *(fp):* The Royal Ballet, Royal Opera House, 25 October 1968

1971

THE TALES OF BEATRIX POTTER An EMI Films production, produced by Richard Goodwin and directed by Reginald Mills, *(m):* John Lanchbery, *(sc):* Christine Edzard, *(masks):* Rostislav Doboujinsky, Recreated as a ballet by Anthony Dowell and Christopher Carr, *(sc):* Christine Edzard with Catherine Goodley, Masks: Rostislav Doboujinsky, *(fp):* The Royal Ballet, Royal Opera House, 4 December 1992

MEDITATION FROM THÄIS *(m):* Jules Massenet, *(c):* Anthony Dowell, *(fp):* Gala Performance, Adelphi Theatre, 21 March 1971

1976

A MONTH IN THE COUNTRY *(m):* Frédéric Chopin, arranged by John Lanchbery, *(sc):* Julia Trevelyan Oman, *(fp):* The Royal Ballet, Royal Opera House, 12 February 1976

FIVE BRAHMS WALTZES IN THE MANNER OF ISADORA DUNCAN *(m):* Brahms, *(c):* David Dean, *(fp):* Ballet Rambert 50th Birthday Performance, Sadler's Wells Theatre, 15 June, 1976. *(fp)* The Royal Ballet: Royal Opera House, 23 November, 1976

1979

SALUT D'AMOUR À MARGOT FONTEYN *(m):* Edward Elgar, *(c):* William Chappell, *(fp):* The Royal Ballet, Royal Opera House, 23 May 1979

1980

RHAPSODY *(m):* Sergei Rachmaninov, *(s):* Frederick Ashton, *(c):* William Chappell, *(fp):* The Royal Ballet, Royal Opera House, 4 August 1980

SOUPIRS *(m):* Edward Elgar, *(c):* Julia Trevelyan Oman, *(fp):* Anthony Dowell Ballet Gala, London Palladium, 30 November 1980. *(fp)* The Royal Ballet: A Knight at the Ballet Gala to mark the end of Anthony Dowell's Directorship of The Royal Ballet, 23 May 2001

1986

NURSERY SUITE *(m):* Edward Elgar, *(fp):* The Royal Ballet School, in 'Fanfare for Elizabeth' Gala Performance, Royal Opera House, 21 April 1986

Frederick Ashton died in his sleep on 19 August 1988 at the age of 83.

Biography: *Secret Muses: the Life of Frederick Ashton* by Julie Kavanagh, 1996, London, Faber and Faber.